**DATE DUE**

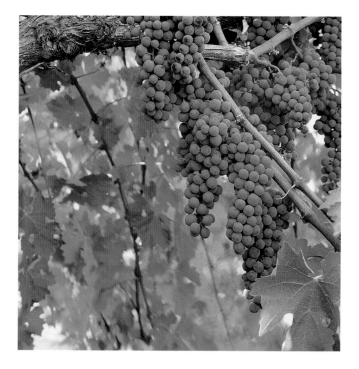

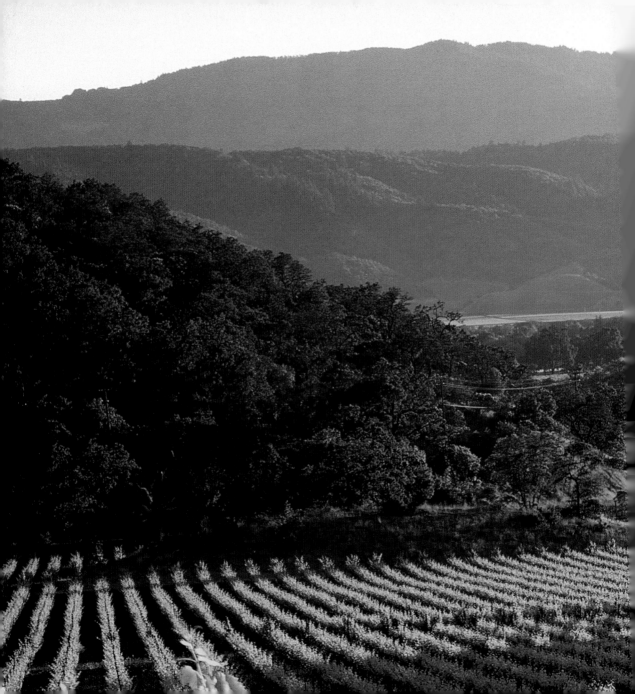

# *Hidden* NAPA VALLEY

## PHOTOGRAPHS BY WES WALKER

### EDITED BY PETER BEREN
### INTRODUCTION BY LINDA REIFF

Welcome
BOOKS

NEW YORK

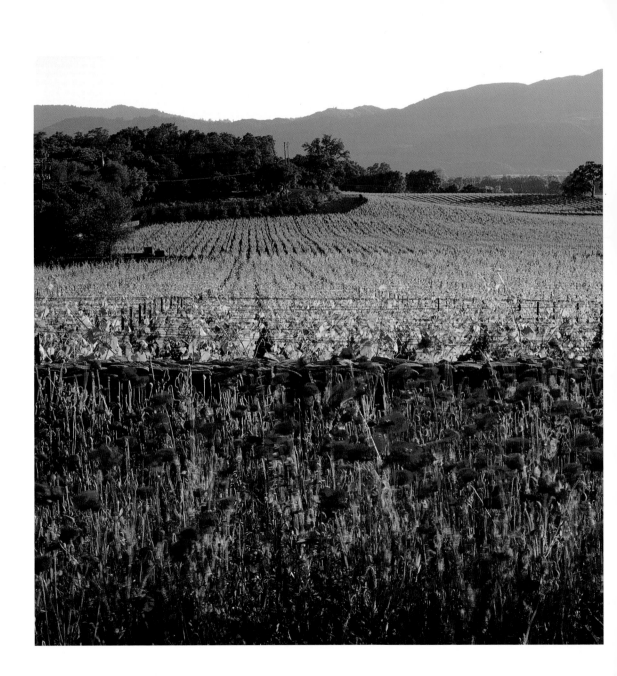

# Foreword

EACH SEASON IN THE NAPA VALLEY stands alone in its extravagance and meets the eye with a brilliant abundance. Fields of wild poppies and mustard burst forth in early spring, followed by acres of vineyards breaking bud. Summer's longer, hotter days turn vineyards, heavy with fruit, a lush green against hills of drying grasses. After harvest, as the days cool and shorten, the eye is met with vibrant golds and vermillion against clear blue skies. Then, an elegant return to the bare architecture of life in winter—gnarled vines, organic earth, rain-filled skies. Yet, the hidden beauty I care about most comes from a deeper source, which sees the valley's rarity as a place in which people and nature flourish. Thanks to the sheer tenacity and foresight of those who preceded us—who were devoted to grape growing, the crafting of fine wines and the preservation of its history—the Napa Valley's beauty is a living testament to the value of keeping landscapes open against urban sprawl. It is my hope that the images I've captured here will not only document but inspire each of us to conserve and protect such beauty for ourselves, and for all who follow. Enjoy!

WES WALKER, *Napa, California*

*Cabernet Sauvignon grapes, just before harvest, at Walker Vineyard.* (page 1)

*Shafer Vineyards at Stags Leap looking west toward Yountville and the Mayacamas Mountains on the western side of the valley.* (preceding spread)

*Red poppies frame the Rudd Vineyards in Oakville. The vines seen here are Petite Verdot, used for blending with Cabernet Sauvignon.* (opposite)

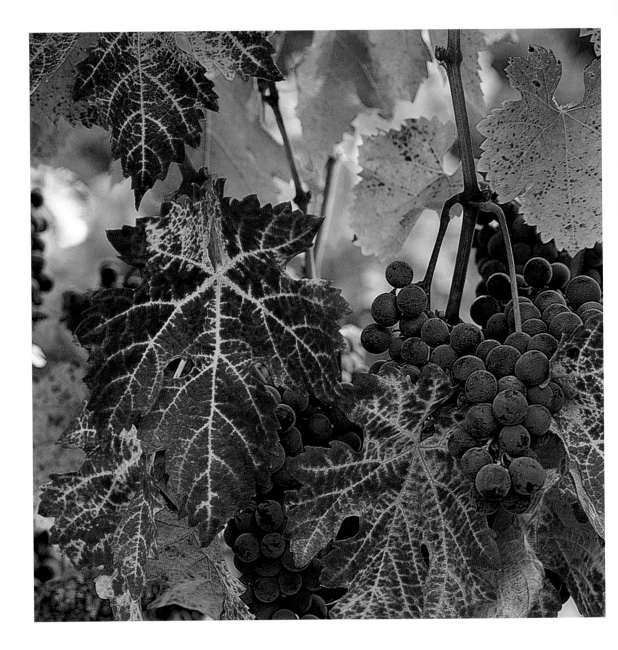

# Introduction

THERE IS A MOMENT IN LATE FALL when it feels like I have Napa Valley all to myself. The time is not set, it is always a surprise, and when it arrives I welcome and relish it. Harvest is over and the result of the frenzied activity in the vineyards now rests in the wineries. It is quiet. It is still. The colors have muted. I take a mental snapshot and hold on to it.

I first visited the Valley in the early 1970s, in the back of a station wagon, in tow as my parents studied many vineyards before they planted their own. I remember how breathtaking it was. I thought the old stone winery buildings were perfect settings for the tales I would surely write. I returned to the valley a number of times in different seasons as an adult and with a much better appreciation for a place that offered so much beauty, where agriculture had not just been preserved but flourished, and where the people were more welcoming and gracious than any I'd ever known.

One cannot help being swept away by Napa Valley and I succumbed in the summer of 1995, moving here to accept a job that has allowed me to delve into, deeply respect, and fall in love with all that it has to offer aesthetically and substantively.

While Napa has earned its title as America's legendary wine region, people are often surprised to learn, in fact, how geographically small it is. Napa Valley vineyards produce only 4% of all California wine, and its total vineyard acreage is just one-eighth the size of Bordeaux. But within this slice of heaven lie many joys. The diverse terrain

*Cabernet Sauvignon grapes shortly before harvest on Spring Mountain.*

provides for a wide variety of world class and memorable wines. Those wines are now matched in character and quality by our restaurants, food purveyors, gardens, inns, spas, educational programs and entertainment.

Much has been written about the splendor and bounty of the valley. But nothing can capture it as well as your own eye, or the eye of a vibrant and brilliant photographer who loved the place as much as anyone could. Wes Walker lived here for twenty-eight years. He tilled the soil as a dedicated grape grower and he participated in the valley's life as a respected community leader. He photographed the valley for years celebrating the landscape, the light, the vineyards, grapes and harvests. Then, he opened his eyes to the architecture, the art, the produce, the caves, the restaurants and the culture that had grown up around the wineries. His pictures chronicle the grace of the valley, its evolution and its astonishing aesthetic in seemingly all matters. This passion for the valley seems to burst through these pages. Thank you, Wes, for creating something that we can all hold onto.

<div align="right">

LINDA REIFF, *Executive Director, Napa Valley Vintners*

</div>

*Entrance to the wine caves at Antica Napa Valley. The winery's name is a portmanteau
of the family name of the owners, Antinori, and California.*

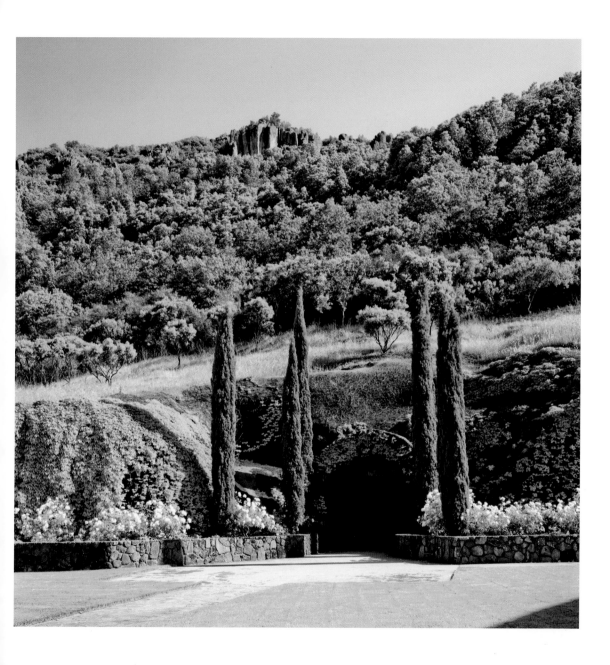

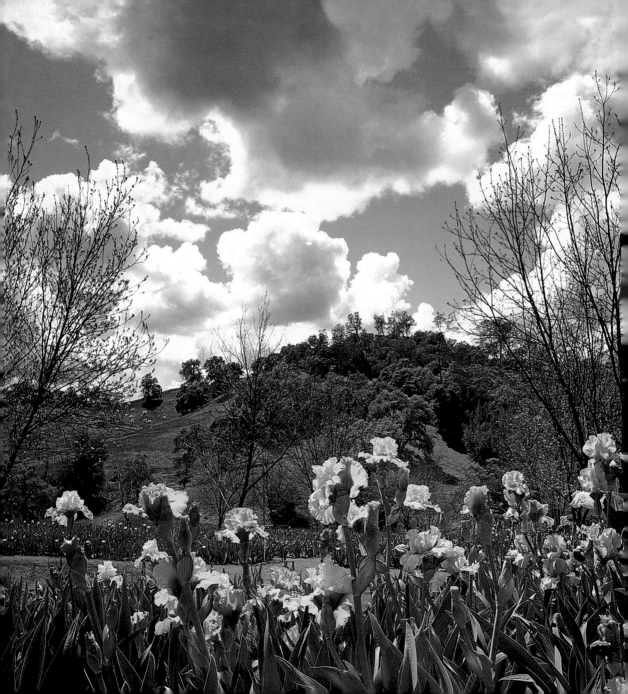

# SPRING

A glorious time! Vines are being reborn. Sap begins to flow upward. Days are warming. Buds swell, popcorn fuzz peeks out, and tiny iridescent green leaves and stems stretch forth. These fragile shoots are vulnerable and need protection. They are tender and tasty to rabbits, deer, and insects, perfect for mildew, and can be blackened by frost. Wine growers are guardians and guides during these critical times.

Randle Johnson, viticulturist

*Napa County Iris Gardens. Located in Steele Canyon, near Lake Berryessa.* (preceding spread)

*The pond and vineyards at Artesa Winery with spring mustard in bloom.*

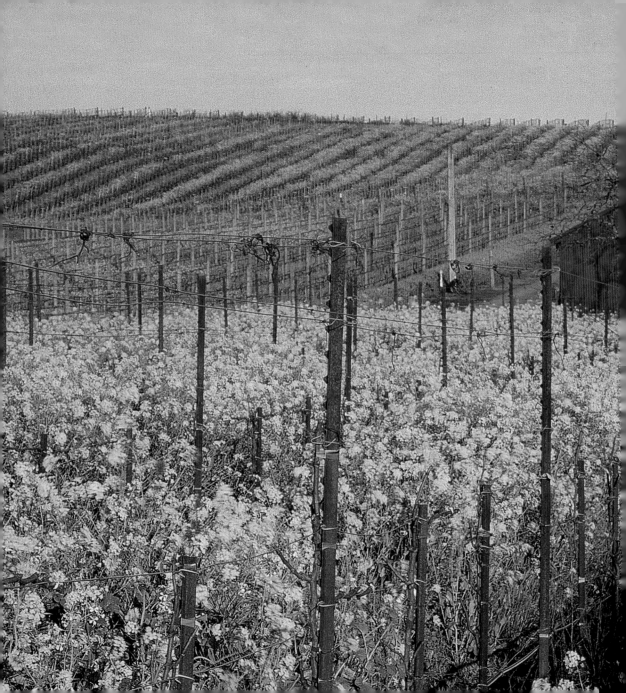

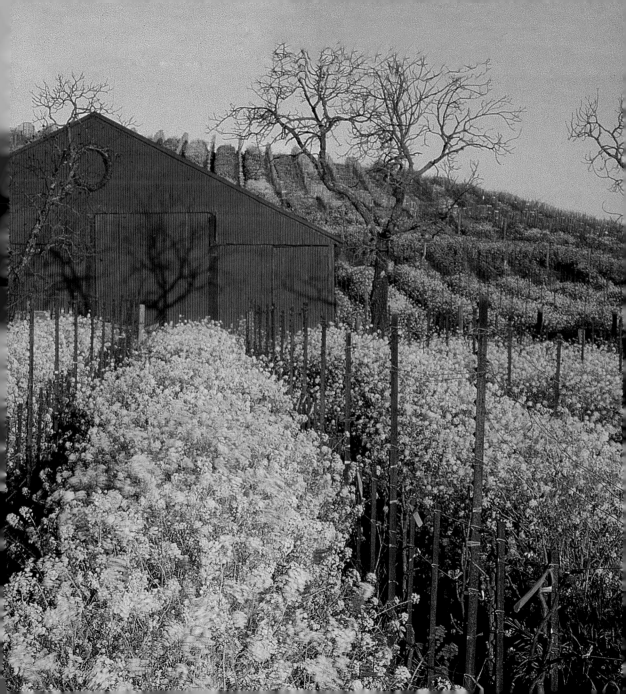

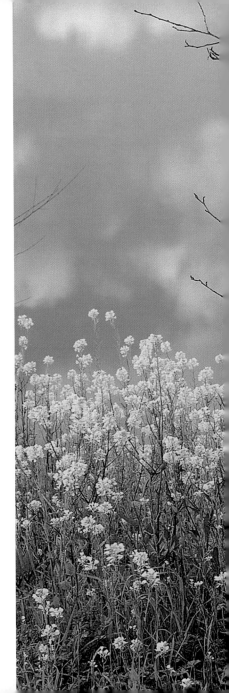

WHEN the mustard grass is in bloom, Napa is perhaps the most beautiful place in California.

Roger Rapoport, travel writer

*Springtime mustard in the vineyards and a red barn in the Carneros region. The barn was relocated from Marysville and reconstructed in 1940, and has been known by the locals as "Muir's Barn." (preceding spread)*

*Late winter mustard in a vineyard by the Artesa Winery pond. Artesa Winery used to be known as Codorniu Winery. Its Spanish-owned winery is an architectural marvel, built into an existing hill.*

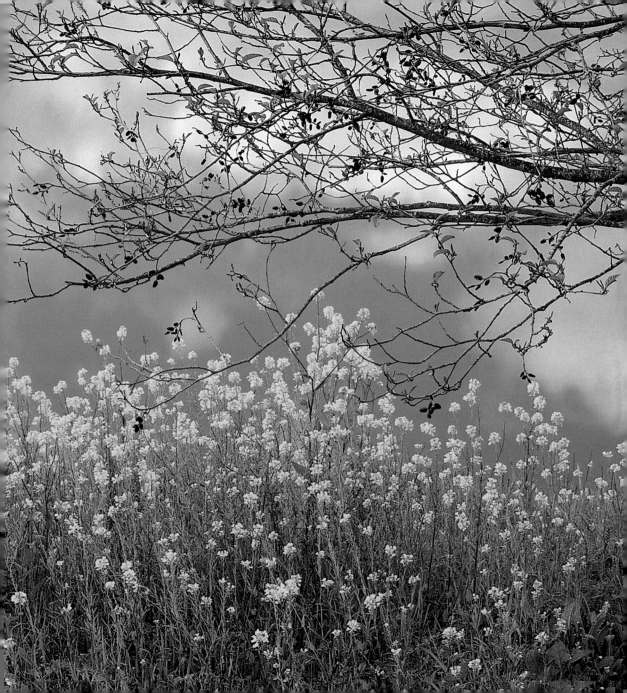

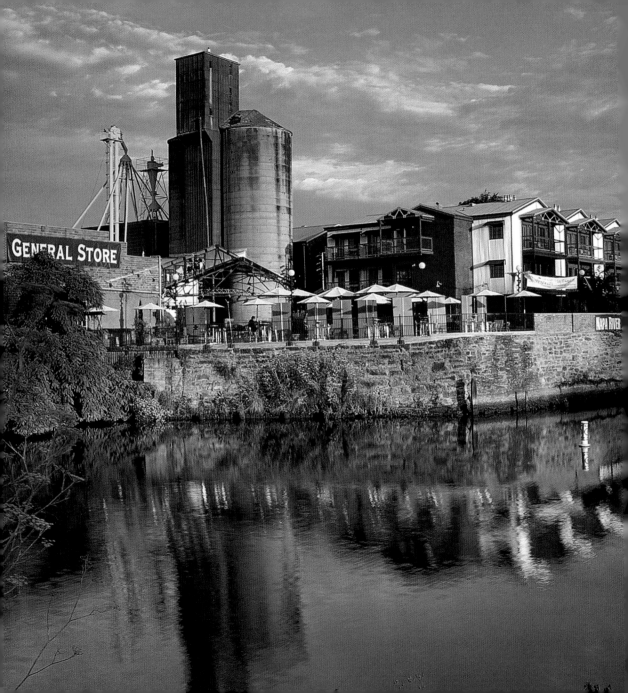

**VITICULTURE is**
a profound and ancient
art. The simplest of
farmers, if it is their
calling, may triumph in
it; the ablest of scientists
may be baffled by it.

Idwal Jones, wine connoisseur

*The Napa River with the historic Old Mill*
*(now the Napa River Inn) and the boat dock on the river in*
*downtown Napa. Built in 1884 and listed in the National*
*Registry of Historic Places, the Napa Mill is the largest historic*
*redevelopment undertaking in the history of Napa.*

THE beauty of the wine is not like the beauty of an autumn leaf on the vine, or of vineyards on rolling hills, or of the girl who is always in the advertising posters picking the grapes. The beauty of wine is a controlled abstract beauty expressing the intentions of the artist.

To call the winemaker an artist is to pose practical problems. One rarely knows his name, but one can be sure that associated with every glass of great wine is an artist.

William B. Fretter, winemaker

*Sculptures by local Napa artist Gordon Heuther adorn the vineyards of Artesa Winery, located in the Carneros region of the Napa Valley.*

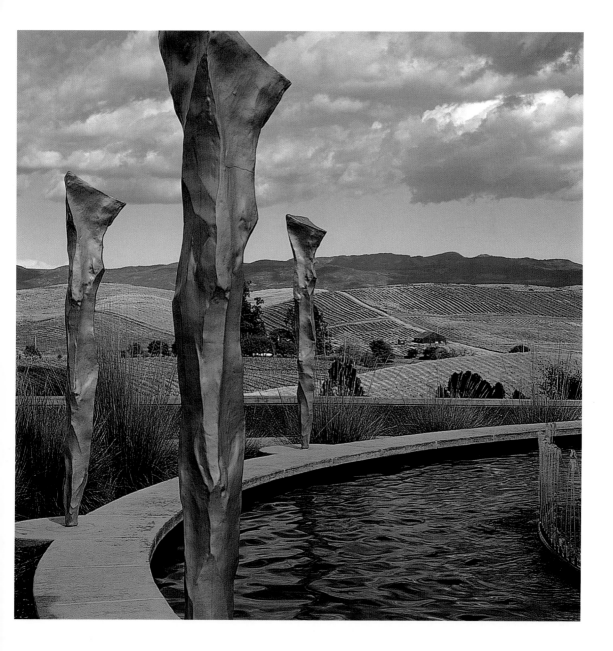

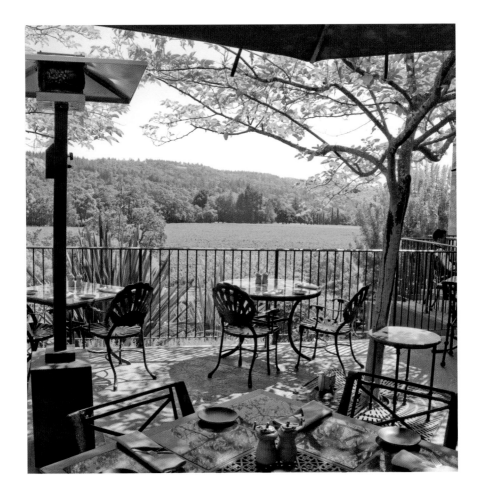

*Patio outside the restaurant at the Culinary Institute of America.*

*Culinary Institute of America at Greystone. The building formerly housed
the Christian Brothers' Greystone Winery.* (opposite)

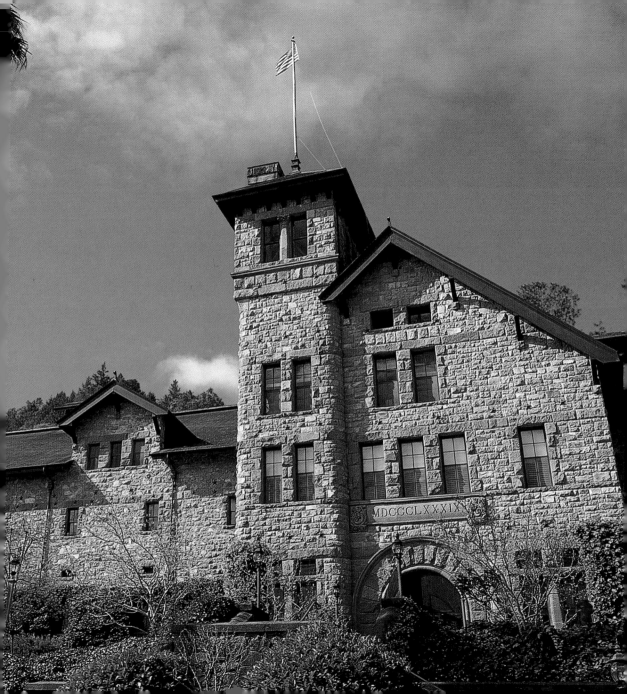

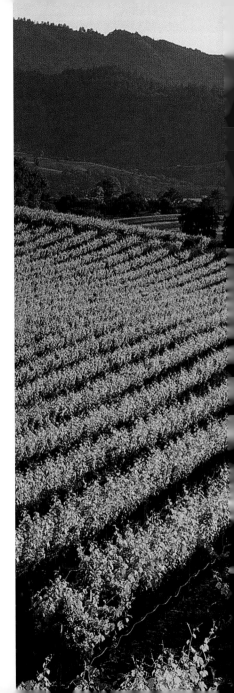

WINE is sunlight,

held together by water.

Galileo

24

*Late spring sunset over the Cabernet Sauvignon vines of*
*Screaming Eagle Vineyards. Screaming Eagle is owned by*
*Stanley Kroenke (Andy Erikson, winemaker) and produces*
*a Cabernet Sauvignon that has achieved cult status.*

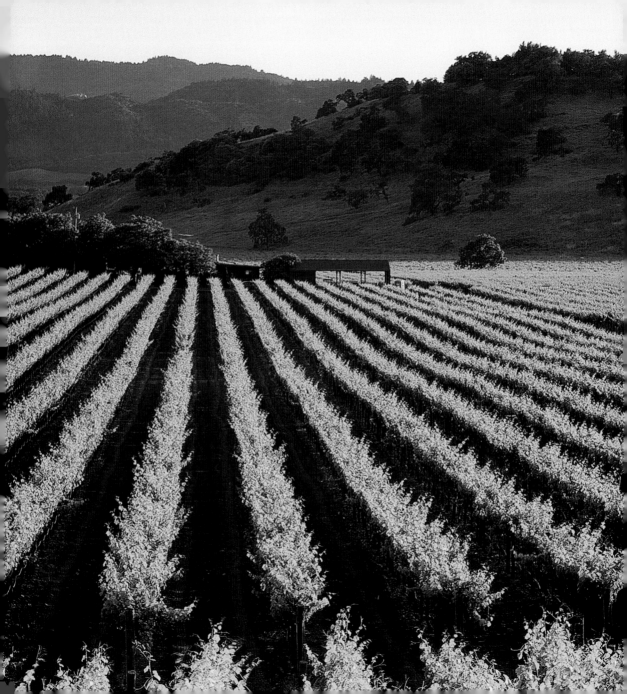

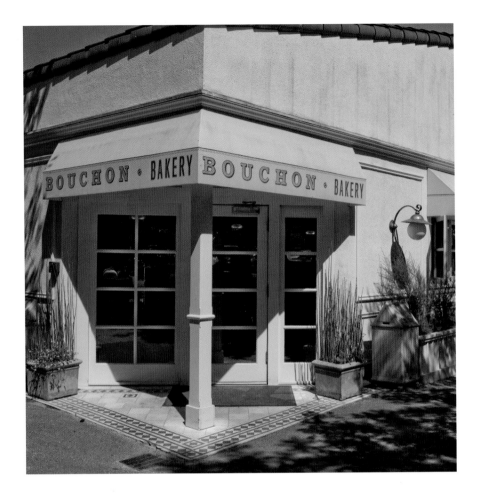

*Bouchon Bakery was originally created by chef and restauranteur Thomas Keller to provide bread for his nearby restaurants, The French Laundry and Bouchon, before opening up to the entire community in 2003. A selection of breads from Bouchon Bakery.* (opposite)

*Opus One winery in Oakville was founded by Robert Mondavi and Baron Phillipe de Rothschild. Designed by architect Scott Johnson, this extraordinary building was completed in 1991.* (following spread)

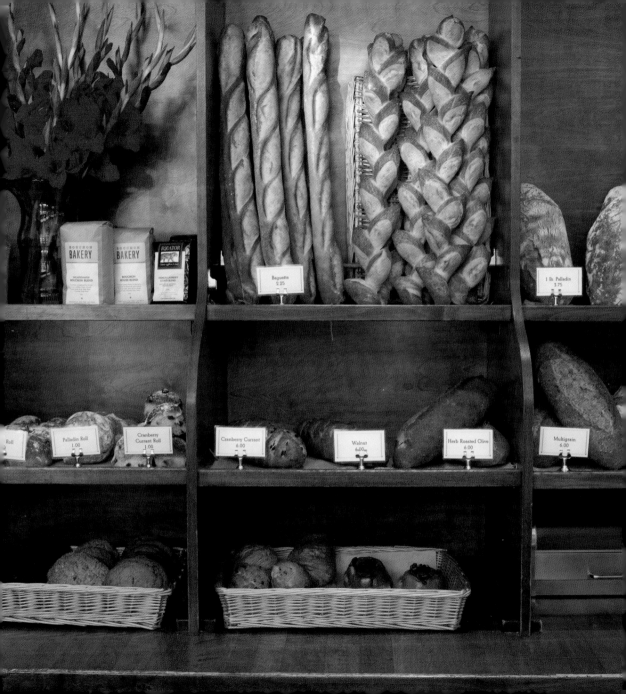

BOUCHON
BAKERY

BOUCHON
BAKERY

EQUATOR

Baguette
2.25

1 lb Palladin
3.75

Roll

Palladin Roll
1.00

Cranberry
Currant Roll
1.00

Cranberry Currant
6.00

Walnut
6.00

Herb Roasted Olive
6.00

Multigrain
6.00

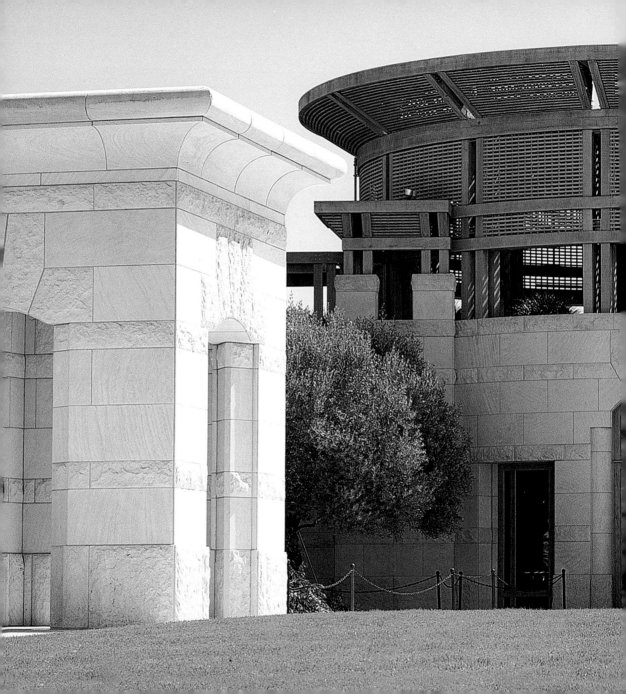

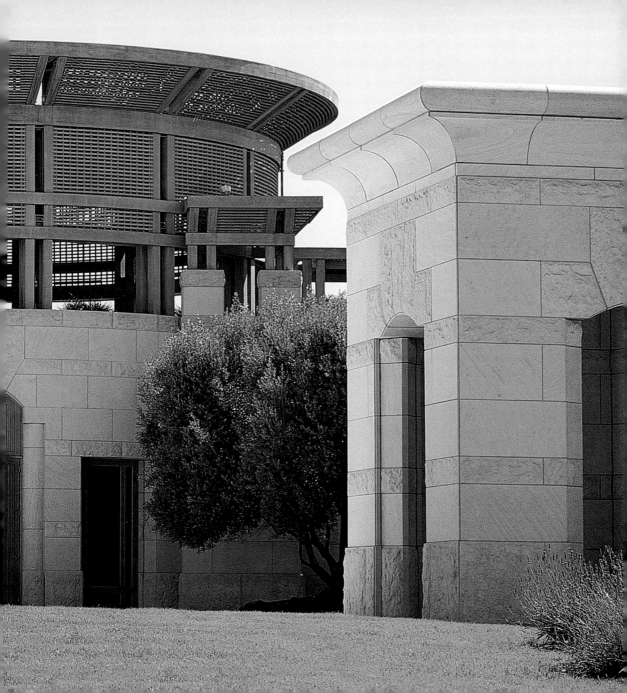

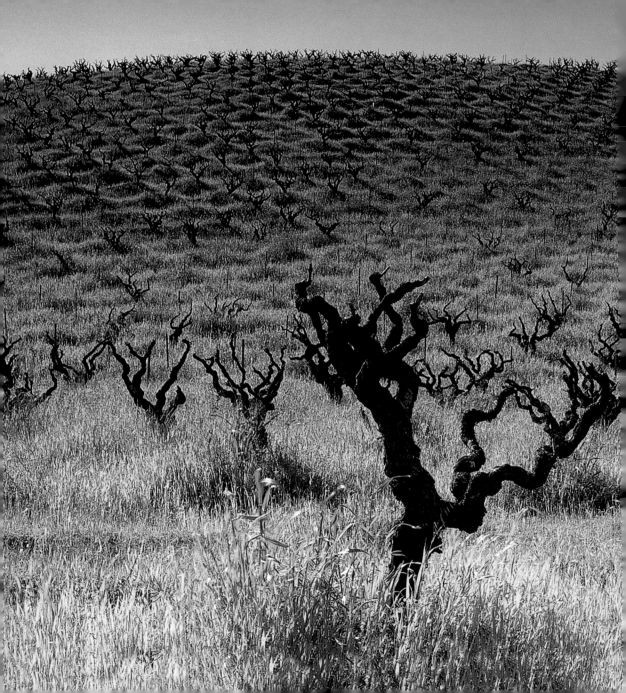

WINE is the most civilized
thing in the world.

Ernest Hemingway

*Seventy-year-old zinfandel vines on the Brandlin Ranch,*
*now owned by Cuvaison Winery.*

EVEN by California's lavish standards, the valley has long been notable for exceptional fecundity—a sort of agricultural Eden—a gift of soils.

Cheryll Aimée Barron, journalist

*Rows of vines slope down to a pond at Truchard Vineyards, a family-owned winery in the Carneros region of Napa Valley.*

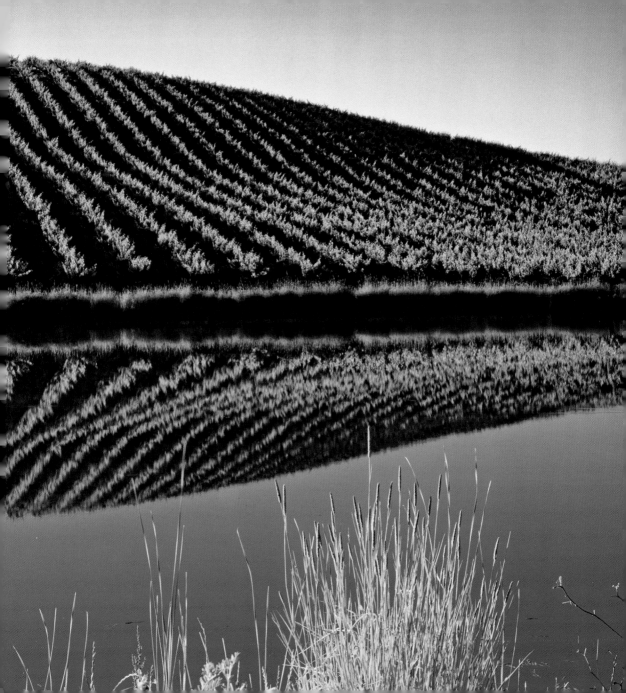

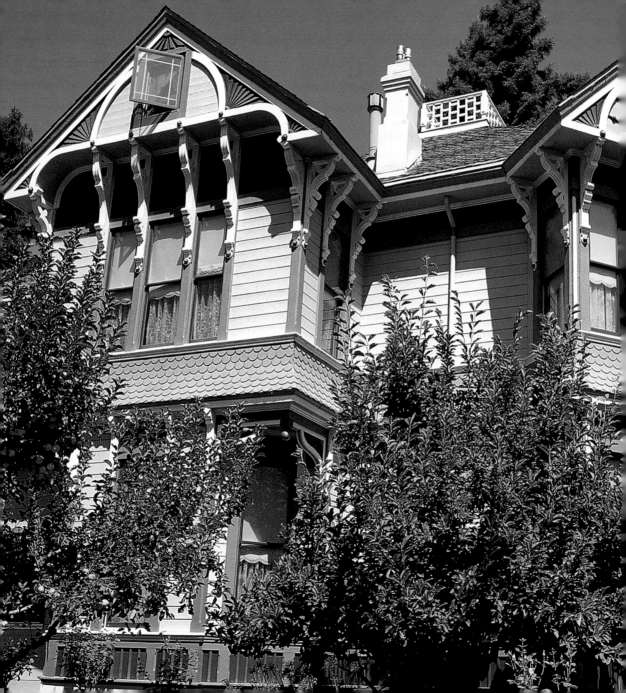

THE lovely Napa Valley
with its neat village, pretty
farms, green trees, and
pretty sites, lay below us,
lit by patches of sunshine
here and there.

William H. Brewer, surveyor

*The Manasse Mansion in downtown Napa City. Built in 1886,
the mansion's architecture reflects both the Stick style of the 1880s
and the Victorian style of the 1890s. It was owned by Emanuel
Manasse, who was originally from Germany and became the
superintendent of the Sawyer Tannery in 1871. Napa had a large
tanning industry for more than one hundred years.*

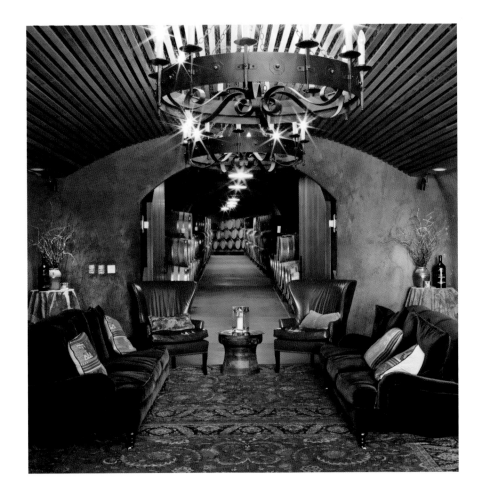

*The cellars at Pride Mountain Vineyards run underneath the hill behind the winery, in caves that were dug between 1999 and 2001. All Pride Mountain Vineyards wines are aged on the estate.*

*One of Pride Mountain Vineyards' hilly plots, found 2000 feet above the floor of the Napa Valley, on Spring Mountain, a part of the Mayacamas range.* (opposite)

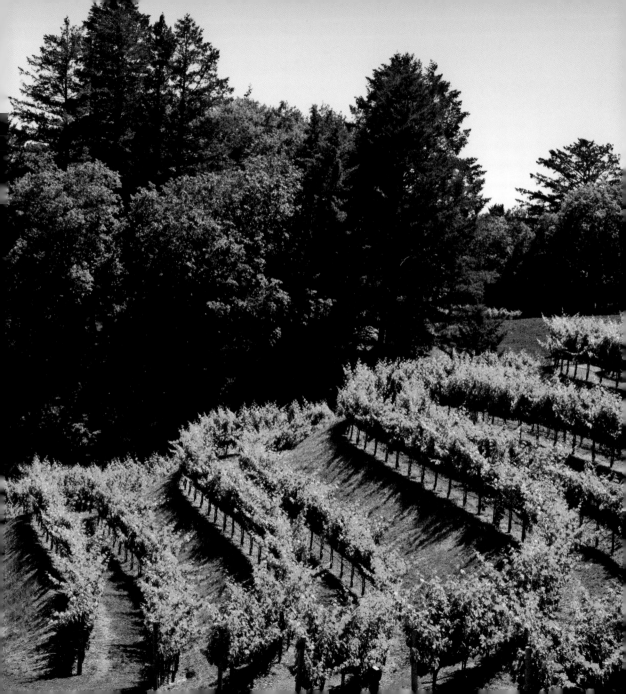

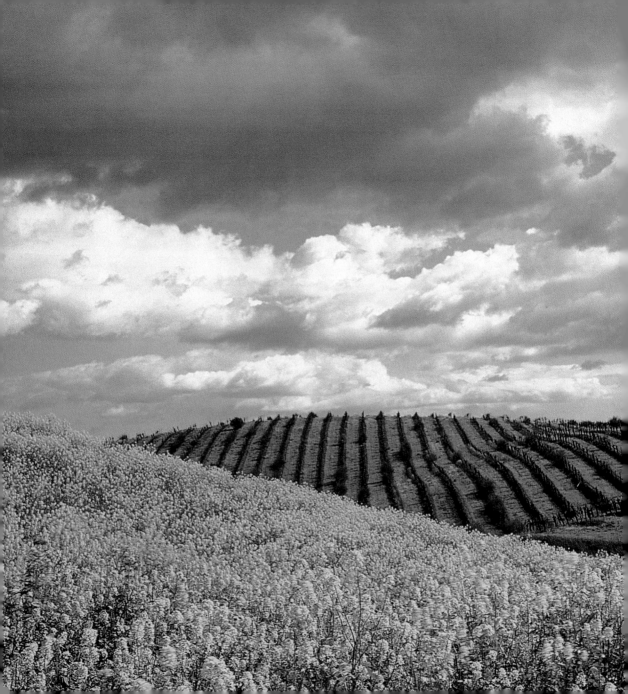

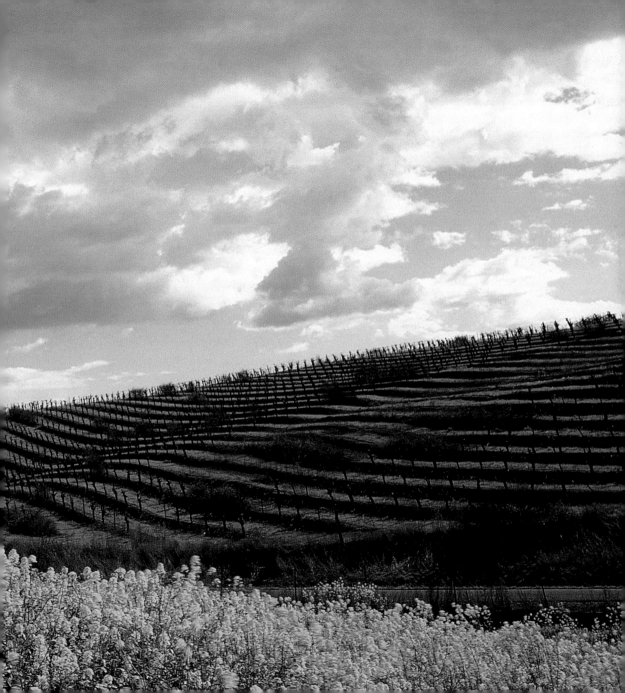

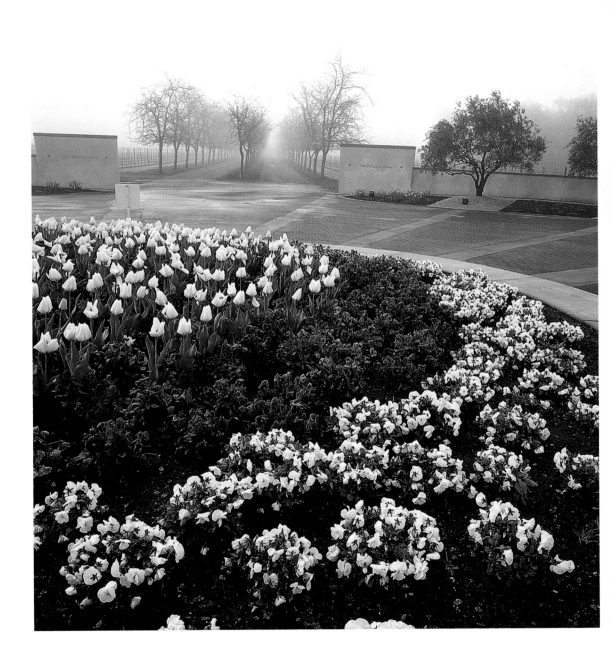

THE pleasant climate in Napa Valley, and the facilities for travel, have already attracted many from the city [San Francisco]. . . . The wealth and culture of the city is in great numbers looking to this valley . . . for a pleasant home where the substantial comforts of rural life may be enjoyed and still the facilities of a rapid transit place them at the doors of the metropolis.

Charles A. Menefee, journalist, 1873

*Mustard and vineyards off Henry Road in the Carneros District of Napa Valley.* (preceding spread)

*Sterling Vineyards in springtime. A panoramic ride on a charming aerial tram accesses this beautiful hilltop winery in Calistoga. Seated tastings on the terraces high over the valley introduce visitors to their classically varietal fruit-focused wine.*

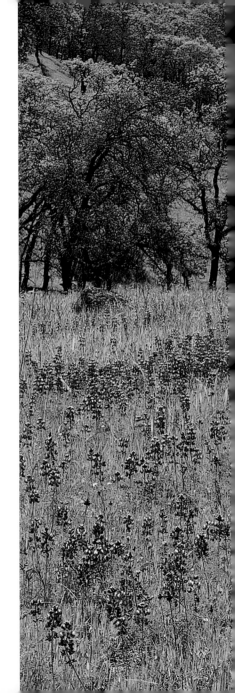

NAPA Valley means many things to many people—from the scenery with fabulous vineyards surrounded by rolling hills, to the landscape bathed in an almost perfect climate.

Robert and Margrit Mondavi, vintners

*Lupine and oak trees at*
*Joseph Phelps Vineyards in St. Helena.*

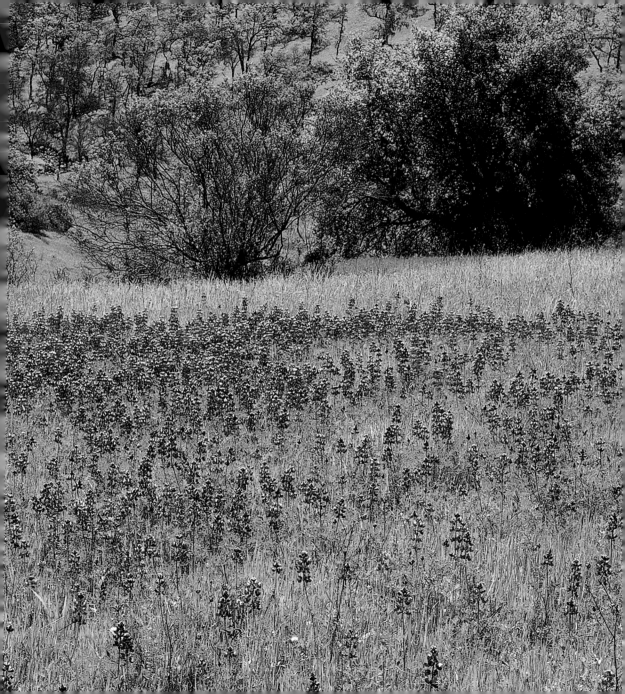

MUSTARD, a cover crop planted between vineyard rows to hold and replenish the soil during winter rains, flips the Valley's summer color scheme on its head: grasses that were dry gold in August are verdant, while once-green vineyards have turned golden.

Thom Elkjer

*Head pruned vines on Cuvaison's Brandlin Ranch on Mount Veeder.*

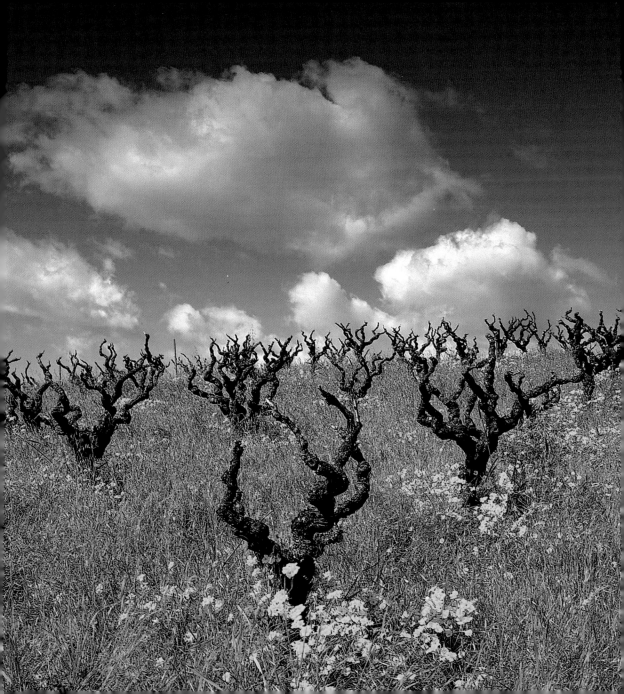

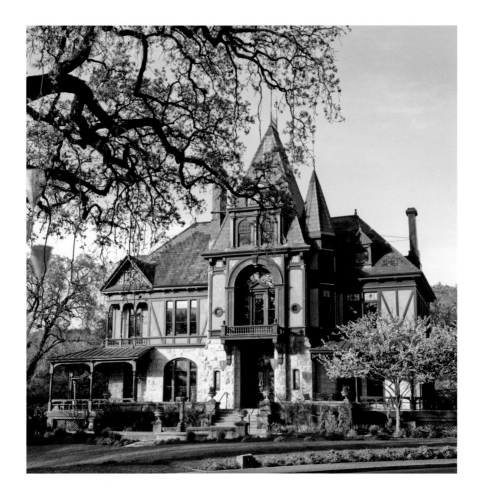

*The Rhine House at Beringer Vineyards. Built in 1884, this seventeen-room Victorian mansion
is modeled after the Beringer family home in Mainz, Germany.*

*Mustard and vineyards off Henry Road in the Carneros District of Napa Valley.* (opposite)

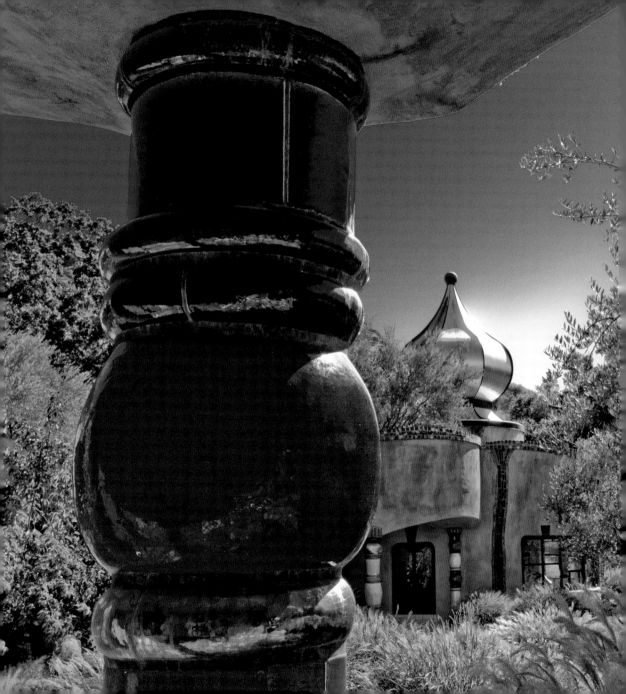

WINE Country. Rows of leafy vines reaching toward the sun; warm, languid afternoons in the dappled sunlight spent sipping a new wine; serene moments of introspection and air perfumed by honeysuckle; and casual, convivial meals enjoyed outdoors with family and close friends. These two words conjure a complete lifestyle—a style of living.

Anthony Dias Blue

49

*Quixote Winery was designed by renowned architect Friedensreich Hundertwasser, who insisted on having no straight lines, a variety of festive colors, and golden turrets on each building.*

THOSE loads and pockets of earth,
more precious than the precious ores,
that yield inimitable fragrance and
soft fire; those virtuous Bonanzas,
where the soil has sublimated under
sun and stars to something finer, and
the wine is bottled poetry.

Robert Louis Stevenson

*A stained glass window by Diane Peterson looks out over the vineyards
of Silver Oak Cellars' Oakville estate.*

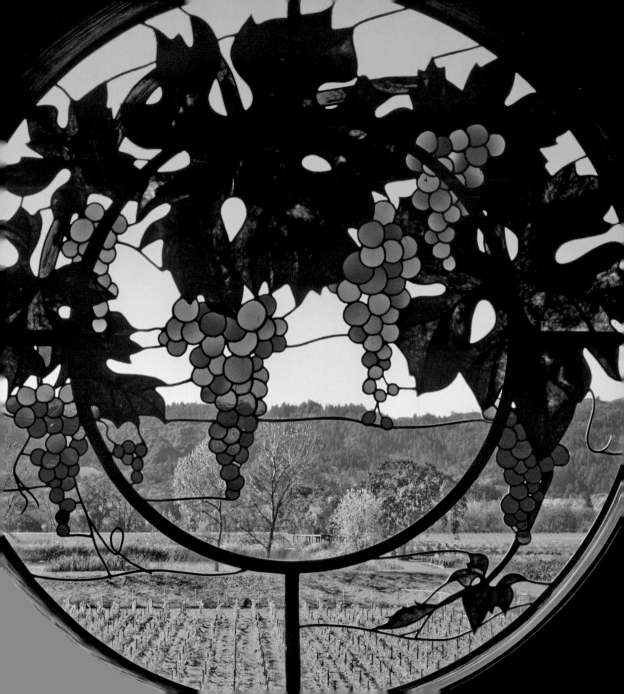

WHEN I came to the Napa Valley I realized I wouldn't have to die to go to paradise. I could work in paradise.

Michael Grgich, vintner

52

*Napa County Iris Gardens, located in Steele Canyon, near Lake Berryessa.*

*These dormant Cabernet vines with mustard growing among them on Walker Vineyard are located on the western hills overlooking the Napa Valley. This vineyard grows select Cabernet grapes for Silver Oak Cellars.* (following spread)

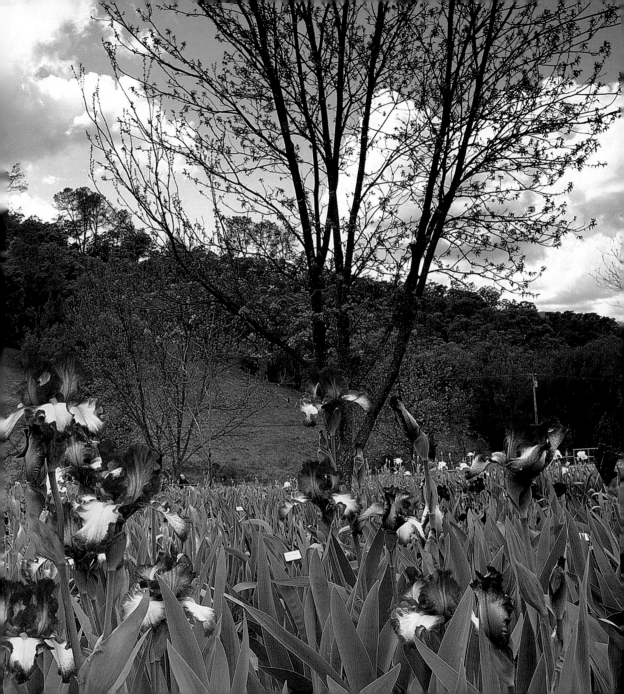

# SUMMER

ON my first exploratory trip to California I visited several winemaking regions . . . on one of these stops an old timer looked at me squinty-eyed and said, 'If you really want to make wine, why are you here? You should be in Napa Valley.' He had a point.

John Shafer, vintner

*Grapes for ZD Wines, a family owned winery located along the Silverado trail, hang from a trellis.* (preceding spread)

*The historic Bergfeld winery was built in 1885, and is now a part of HALL Winery's St. Helena estate.*

OVERHEAD and on
all sides a bower of green
and tangled thicket, still
fragrant and still flower-
bespangled.

Robert Louis Stevenson

*Early summer at Walker Vineyard.*

IN the luxuriance of a bowl of grapes set out in ritual display, in a bottle of wine, the soil and sunshine of California reached millions for whom that distant place would henceforth be envisioned as a sun-graced land resplendent with the goodness of the fruitful earth.

Kevin Starr, California historian

*Duckhorn wineries in St. Helena specializes in premium Merlot wines.*

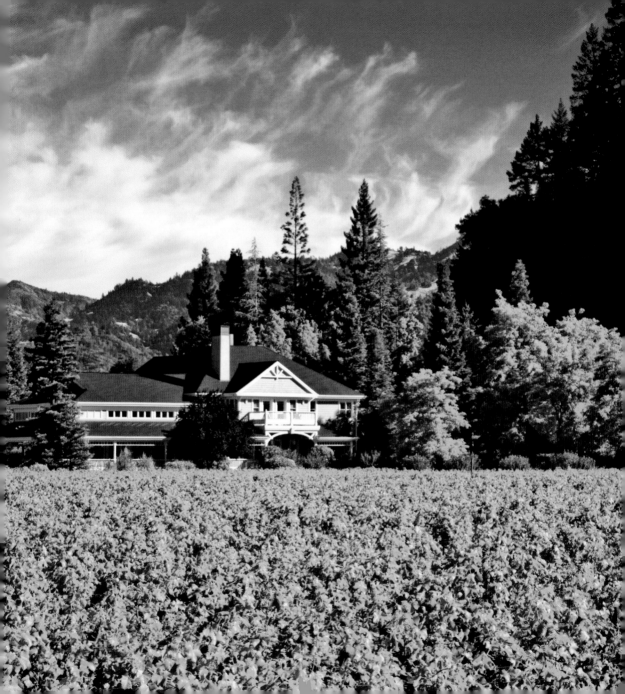

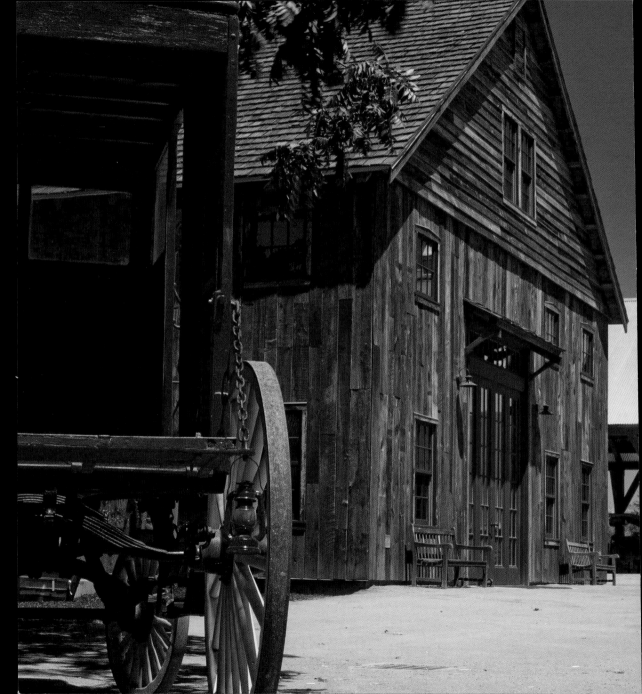

*The Napa Valley Vintners' annual wine auction at Meadowood Resort. Through the event, the Vintners have contributed more than $90 million over nearly 30 years for health care, youth development, and housing programs to help those in need.*

*Nickel & Nickel Winery in Oakville. The Gleason Barn was originally built in 1770 in Meridian, New Hampshire, by the Gleason Family. Spared demolition in 2001, it was carefully restored, dismantled, and shipped in pieces to Nickel & Nickel.* (opposite)

THE most wonderful part of being a chef in Northern California is that you can grow your own salad greens and herbs and lots of vegetables, too, for ten to twelve months of the year. . . . My rule is simple—eat from the garden whenever you can. It's nice to let Mother Nature write your menu.

Cindy Pawlcyn, chef, Mustards Grill

67

*Organic vegetable garden at Mustards Grill in Yountville is a source of fresh vegetables for the restaurant.*

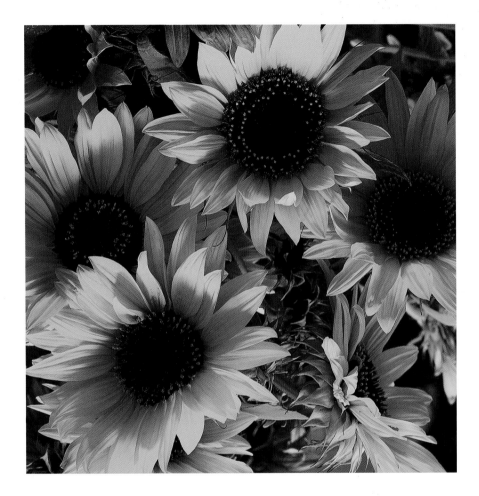

*Sunflowers at the Farmers' Market in St. Helena.*

*The path leading to the entrance of Brix Restaurant and Gardens in Napa.*
*Brix specializes in garden-to-table dining.* (opposite)

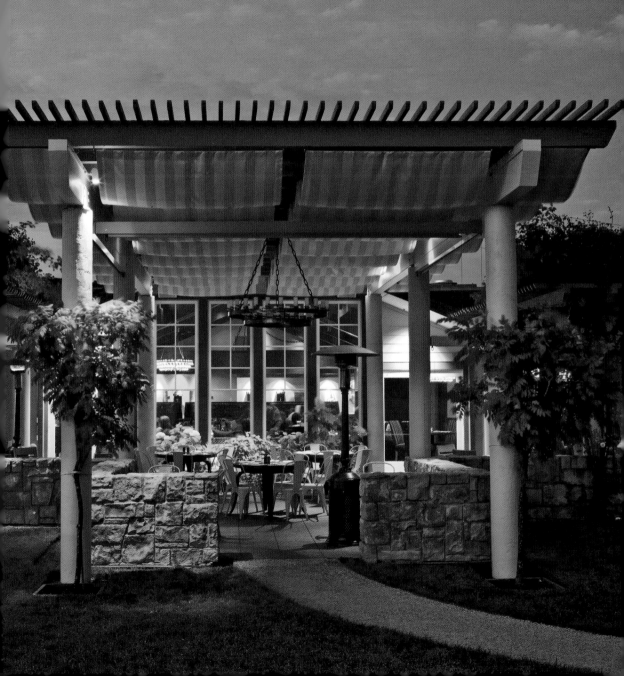

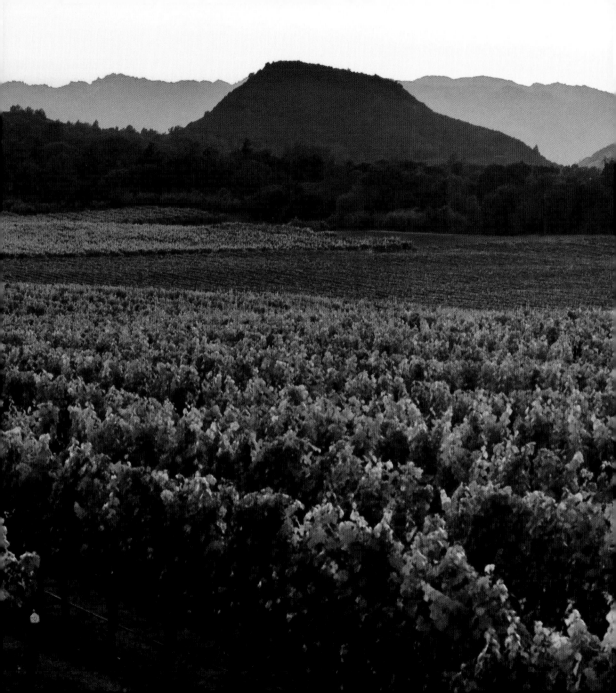

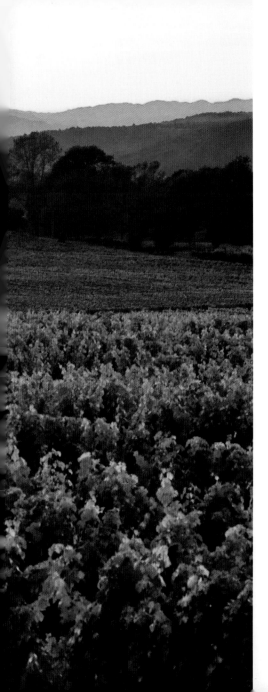

WHEN I take you to the Valley, you'll see the blue hills on the left and the blue hills on the right, the rainbow and the vineyards under the rainbow late in the rainy season, and maybe you'll say, "There it is, that's it!"

Ursula K. Le Guin

71

*Sunset over the vineyards at Antica Winery in Napa.*

*Evening over Antica Winery.* (following spread)

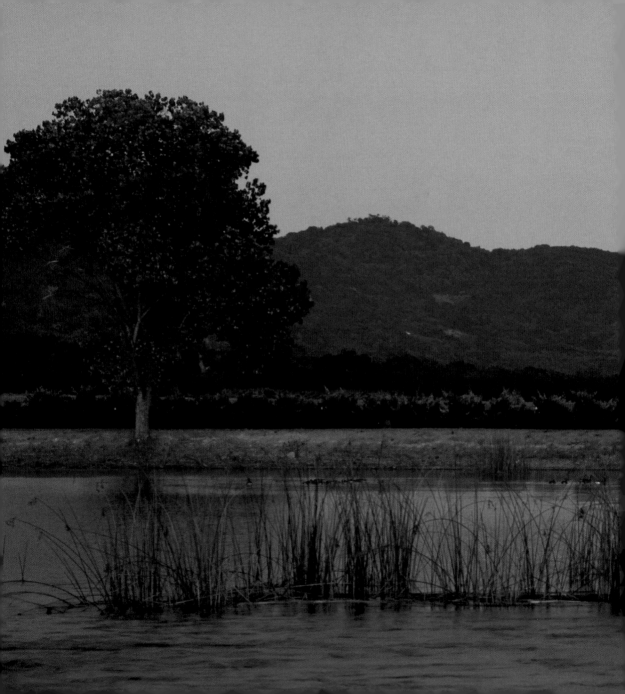

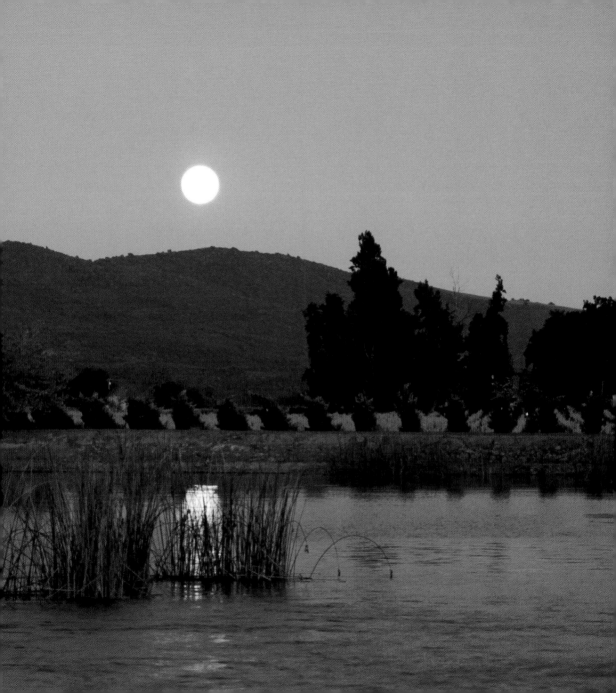

EVEN to the most casual observer, the
Napa Valley is so fertile and productive that
it is popularly believed all one needs to
do is drive a grape cutting into the ground,
then stand back and watch it grow.

Gerald D. Boyd, wine writer

*Flowers line the path to Mumm Napa. Although the name "Champagne" is reserved
for sparkling wines from Champagne, France, Mumm Napa produces award-winning
sparkling wine in the rich tradition of* méthode champenoise.

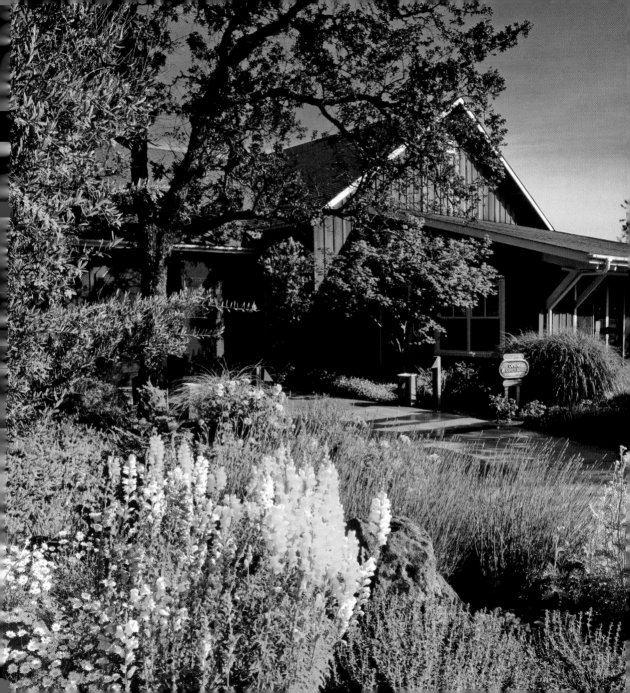

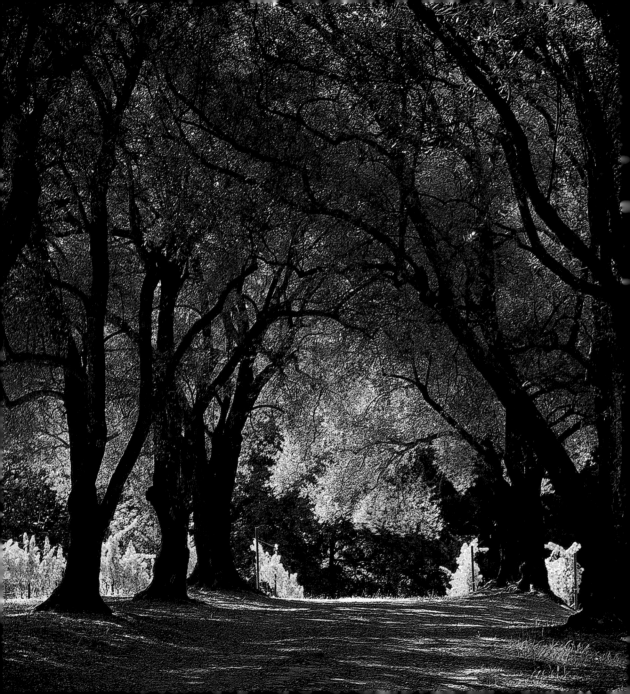

SEEDS begin to mature. Ripening is in full swing. Growers monitor the vines for stress, water judiciously, keep them on the edge, and wait patiently. Fall is approaching. They remove some leaves to allow dappled sunlight to mature the remaining fruit. Fruit is thinned to concentrate flavor intensity in the remaining clusters.

Randle Johnson, viticulturist

*One hundred-year-old olive trees planted by Jacob Schram, founder of Schramsberg Vineyards. Founded in 1862, Schramsberg was the first hillside winery in the Napa Valley.*

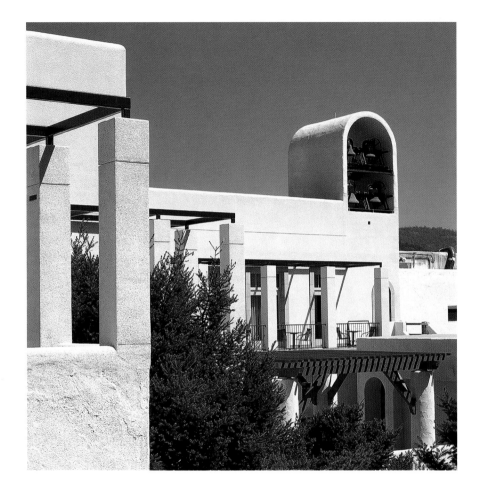

*The bell tower at Sterling Vineyards. Founded by Englishman Peter Newton, the Greek-inspired architecture of the building found a new home for the church bells of St. Dunstan's in London, which was destroyed during World War II.*

*Flower gardens at the foot of the aerial tramway to the winery at Sterling Vineyards.* (opposite)

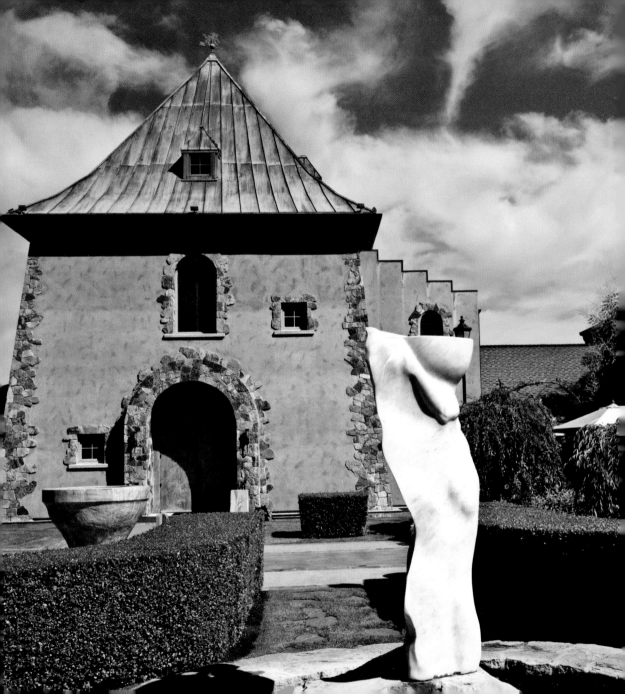

THE introduction of gardens to the Napa Valley paralleled the first plantings of vineyards—around 1860—when horse-drawn buckboards were the only means of transportation, and clearing the land was done by hand and horse. And yet the heritage of these early gardens is even older than their structure. Their creators brought with them the legacies and forms of European homelands and, in these venerable landscapes, provided the foundation of what has made the Napa Valley a symbol of Old World charm.

Molly Chappellet, author

*Like the winery itself, the gardens at Peju Province are a family affair, designed and overseen by founders Tony and Herta Peju, respectively.*

TO enjoy wine is to partake
of a heritage that stretches
back to the beginnings of
civilization and promises to
add continued pleasure to
our future.

Robert Mondavi, vintner

*The Riddler's Pond next to the Hospitality Center at Schramsberg Vineyards is anchored by Larry Shank's sculpture entitled "Riddlers Night Out." It is the "riddler's" job to turn the champagne bottle so that the remnants of the yeast settle in the neck for disgorgement prior to adding the dosage (sugar) to make the bubbles. In order to do this the bottle is placed in a rack neck down and a riddler turns it a quarter turn at a time over many days (even weeks) as the yeast gradually accumulates. It's a tedious job and a night out is always welcome!*

# SUMMER vineyard slopes

Well-ordered.

Lavender's chaos,

Olive trees dust green.

Hot and fragrant

Ancient scents.

Reverend Brad Bunnin

*Harms Vineyards and Lavender Fields are located on the western hills of the Napa Valley. The lavender was originally planted as a buffer to insulate the grapes from the glassy-winged sharpshooter that infected the vines with Pierce's disease. The vineyard now also produces a range of lavender products.*

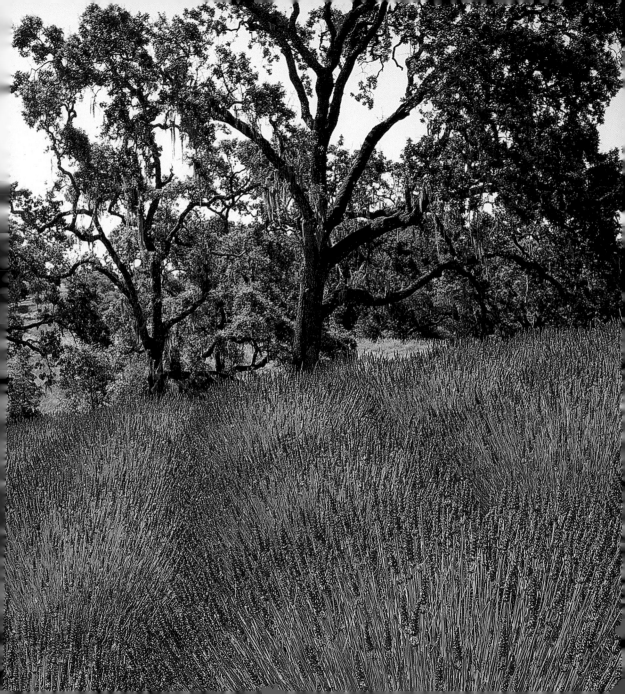

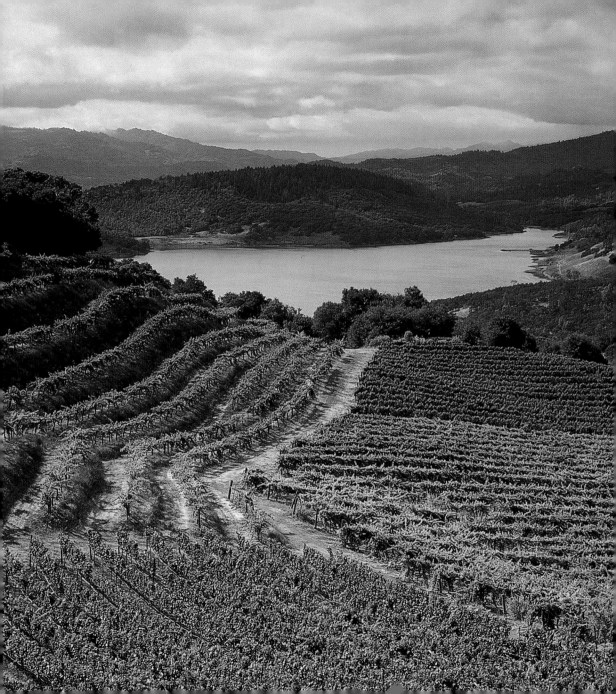

THE vineyards are the world's
most expensive landscaping.
They're so *geometric*. The land
in Napa is stunningly beautiful.
The valleys and the rolling hills—
these sites are as good as you get.

Olle Lundberg, architect

*Long Vineyards. View of vineyards on Pritchard Hill toward Lake Hennessey.*

NAPA Valley was about to achieve something unique in America— again. Wine, lately considered the dubious beverage of immigrants, made in basements, would soon be transformed into a symbol of high culture, and winemakers would be heralded as artists. The owners of wineries themselves would be celebrated as a new class. . . . They would invite the public into a romantic association not unlike that involving movie idols and real royalty.

James Conaway, Napa historian

*Andy Goldsworthy's "Rock Pools" on display in the Hess Collection gallery.*

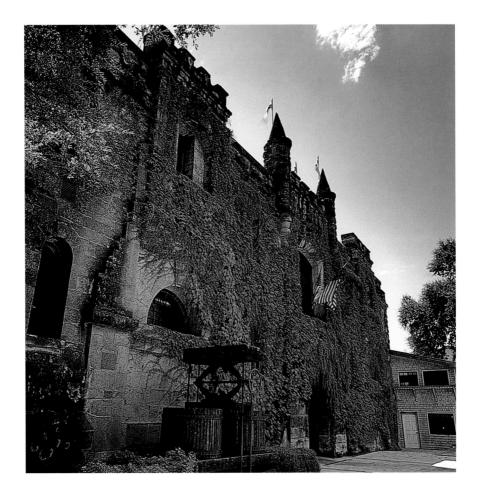

*Old stone winery and Jade Lake at Chateau Montelena.*

*Stony Hill Vineyard on Spring Mountain in St. Helena.*
*View across Riesling vineyard toward Mount St. Helena.* (following spread)

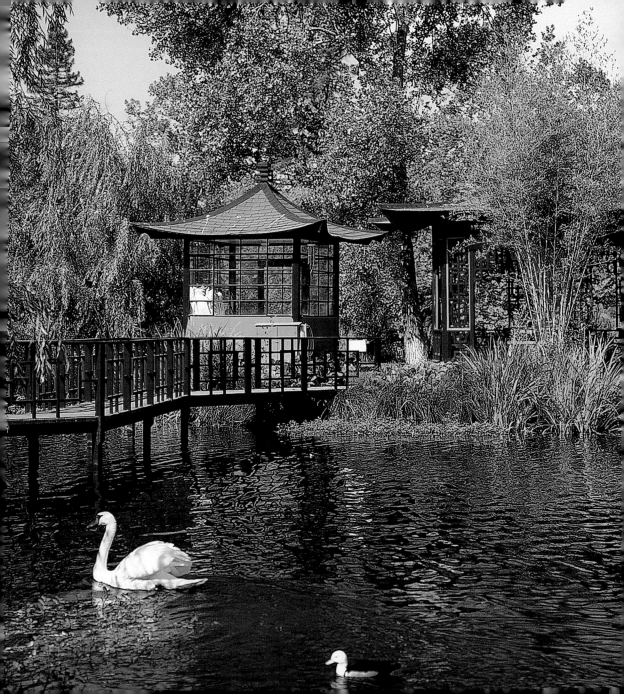

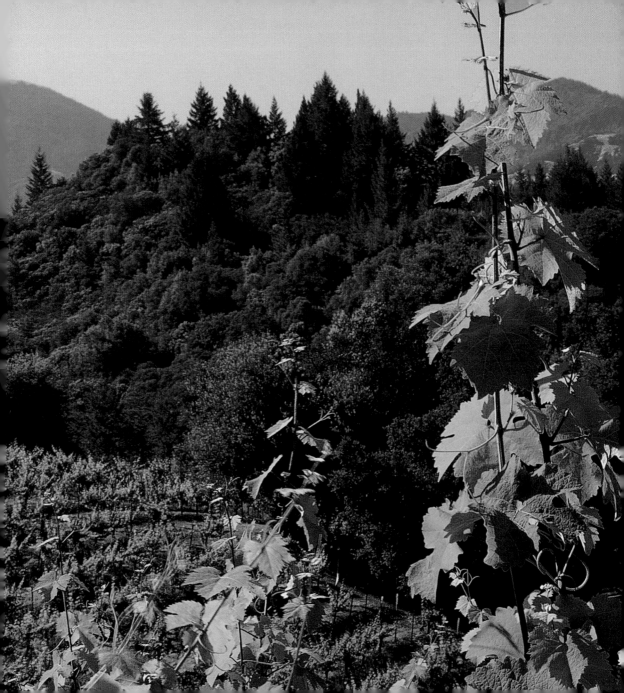

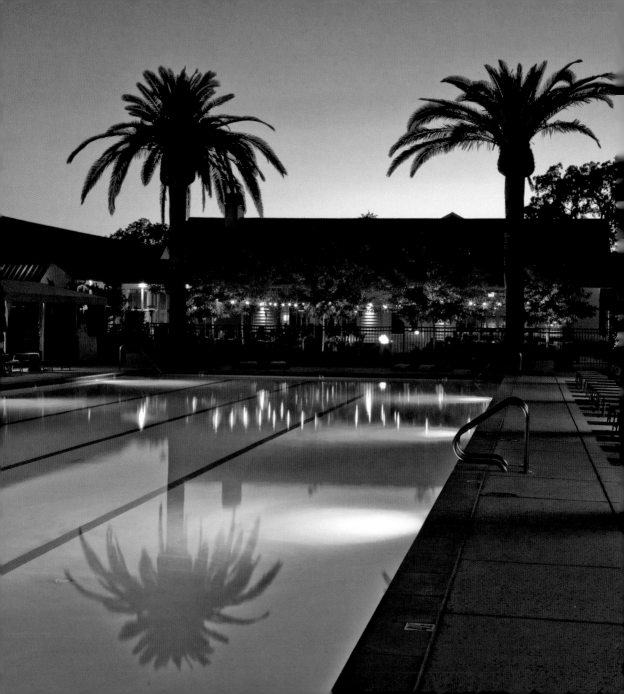

AND there were gardens bright with sinuous rills; Where blossomed many an incense-bearing tree; And here were forests ancient as the hills, Enfolding sunny spots of greenery.

Samuel Taylor Coleridge

*The pool at the Solage Calistoga, a luxurious, 22-acre Napa Valley resort.*

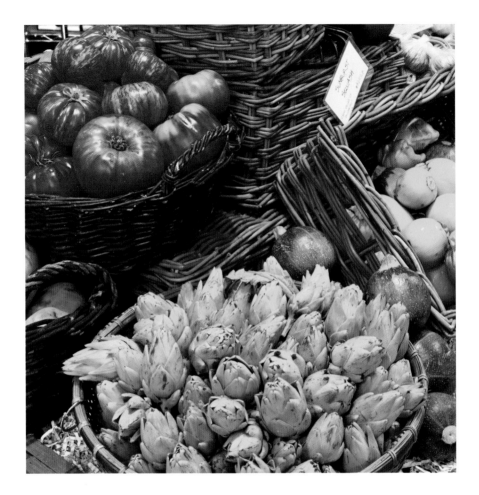

*Fresh tomatoes and artichokes at Dean and Deluca.*

*The exterior of Cakebread Cellars in Rutherford. Cakebread Cellars has developed a reputation for producing world-class wines since its founding in 1973.* (opposite)

MOST folks just came for a visit. Some came for the summer. A few left their pasts behind them and moved in for good.

Lin Weber, historian and author

*Beaulieu Vineyard is one of the longest continually producing wineries in the region.*

ENTER, then, the Rose-garden when the first sunshine sparkles in the dew, and enjoy with thankful happiness one of the loveliest scenes of earth. . . . Roses that stretch out their branches upward as if they would kiss the sun. . . . They blush, they gleam amid their glossy leaves, and never . . . hath eye seen fairer sight.

S. Reynolds Hole

*Mayacamas Vineyards and Winery. Red roses against stone wall of old winery. The winery was built in 1889 by John Henry Fisher, a German immigrant.*

*Gourd and chili peppers in an organic garden at Frog's Leap Winery. An old ledger
revealed that around the turn of the century, frogs were raised there and sold for $.33 a dozen.
Now home to some of Napa's best wines, their motto is "Time's fun when you're having flies!"*

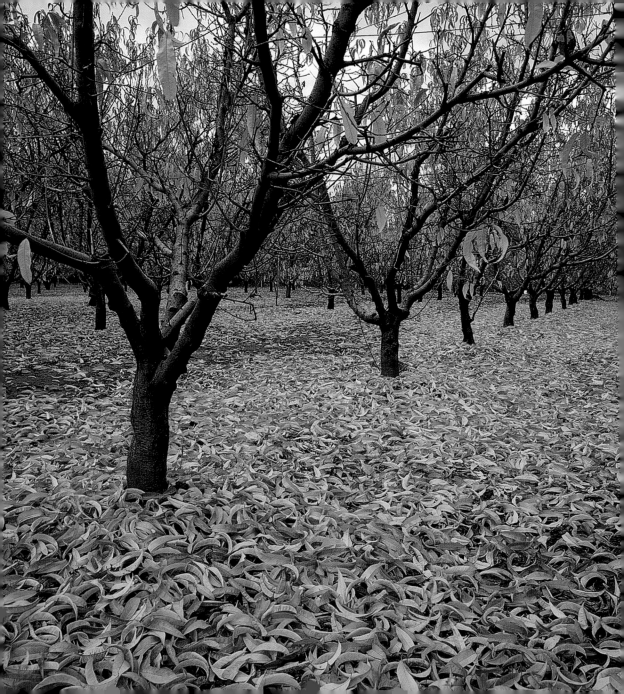

# FALL

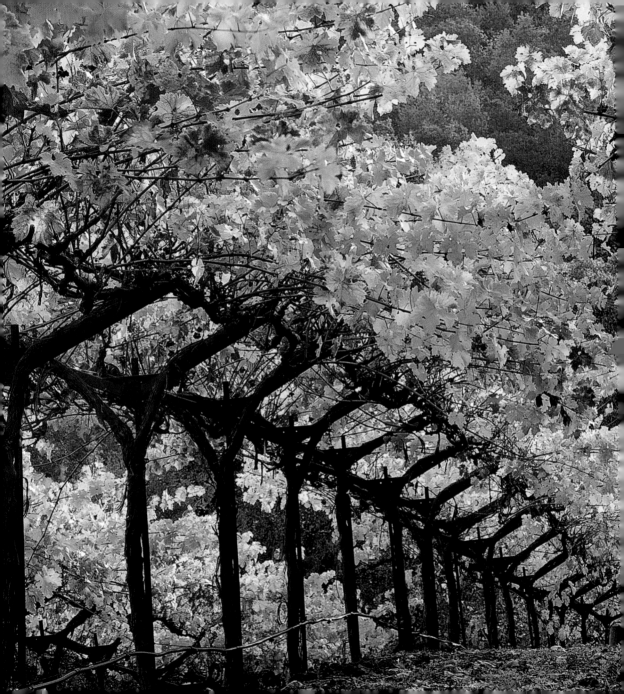

LET us get up early to
the vineyards; Let us
see if the vine flourish,
Whether the tender
grape appear.

Song of Solomon 7:12

107

*Fall leaves in Dr. Wendell Dinwiddies' peach orchard
on the Silverado Trail in St. Helena.* (preceding spread)

*Fall colors of the Walker Vineyard in the western hills
overlooking the Napa Valley. The vineyard produces select
Cabernet Sauvignon grapes.*

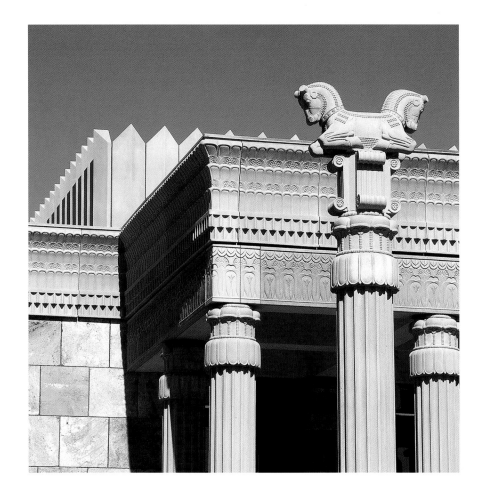

*Darioush, Napa—a winery noted for its Bordeaux style estate wines—implements old world labor-intensive, micro-vineyard management and new world state of the art technology to craft award winning fine wines.*

*Bottega Napa Valley is located in the former Groezinger Estate, one of the oldest wineries in the area.* (opposite)

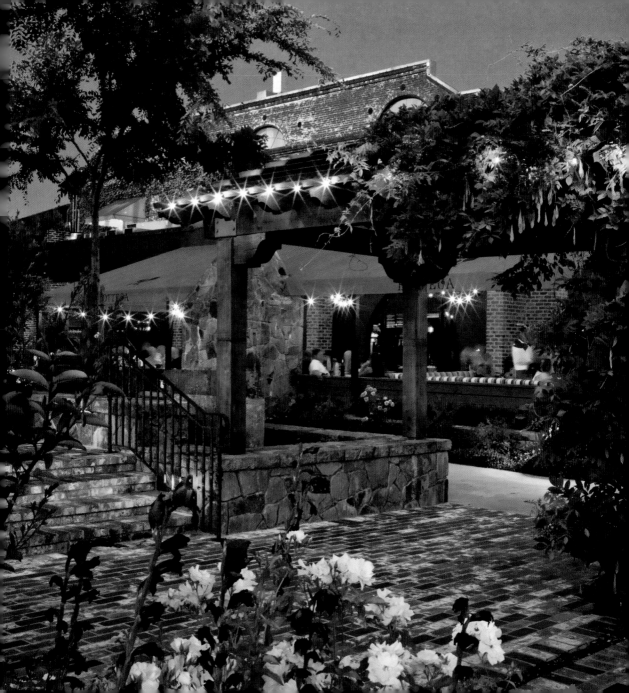

AS you step into the balloon's gondola, your eyes will gape at the towering, billowing fabric overhead, and your heart will race with wild expectation. Once aloft, the wind guides your craft above countryside blanketed with acres of grapes. Up here, the world seems more serene than you ever imagined possible.

Stephanie C. Bell & Elizabeth Janda, travel writers

*A hot air balloon taking off from the Peju Winery in Oakville at sunrise. The balloon is flown by Joyce Anna Bowen, who operates the Bonaventura Balloon Company in the Napa Valley.*

*Fall in the Stelling Vineyard/Far Niente Winery.* (following spread)

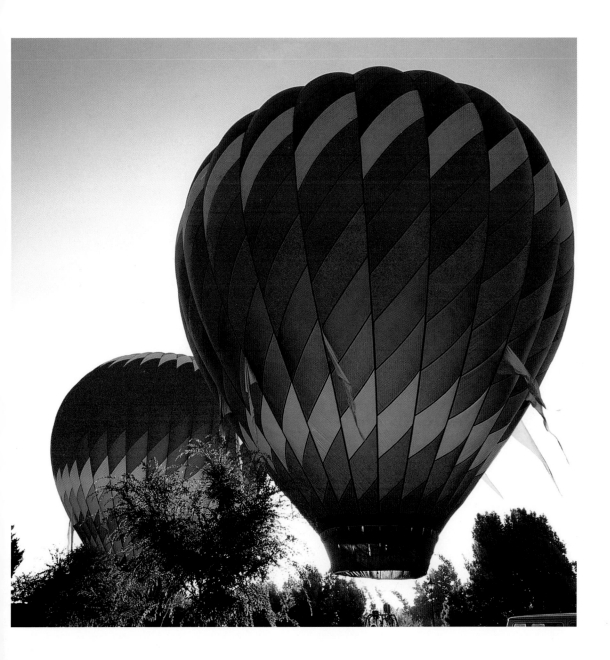

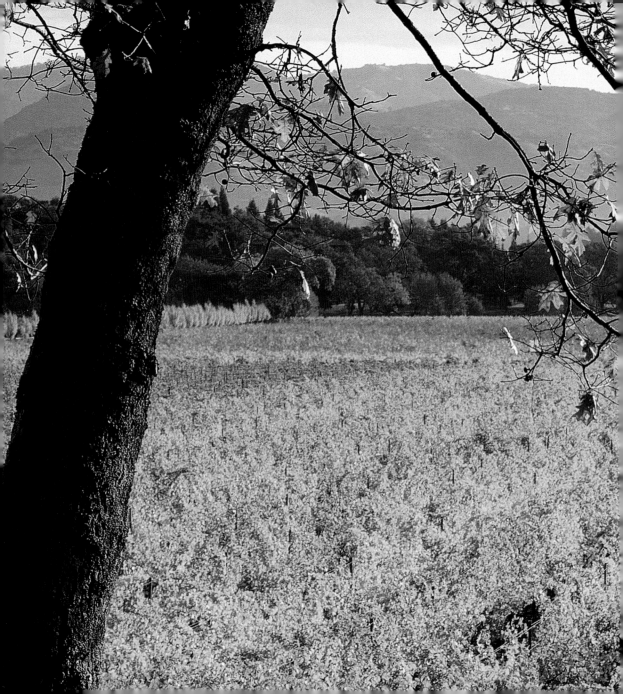

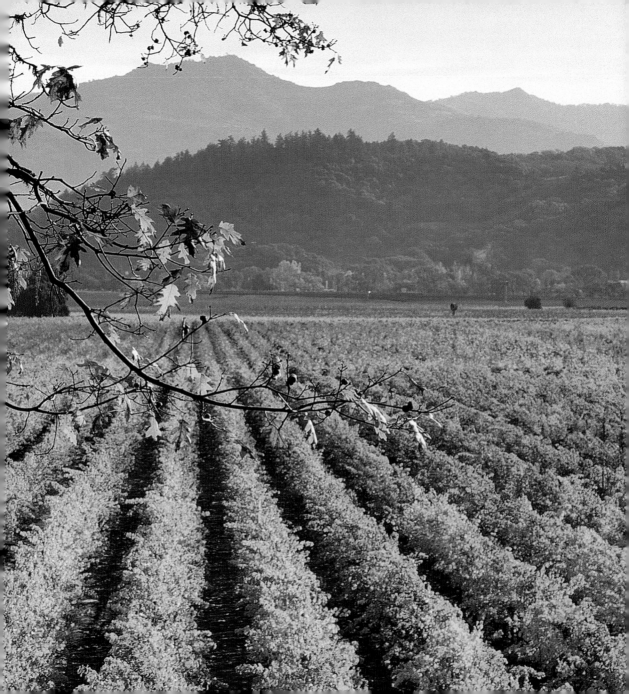

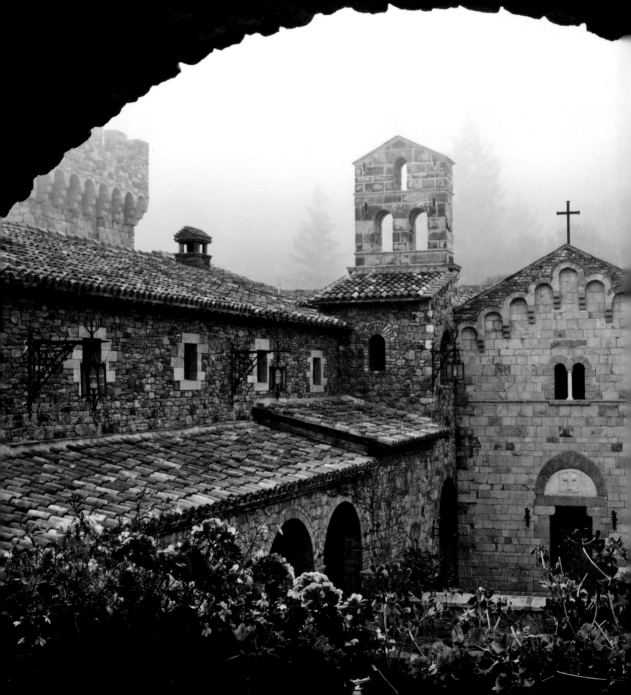

NAPA Valley was gone; gone
were all the lower slopes and
woody foot-hills of the range; and
in their place, not a thousand
feet below me, rolled a great level
ocean. . . . Far away were hilltops
like little islands. Nearer, a
smoky surf beat about the foot of
precipices and poured into all the
coves of these rough mountains.
The colour of that fog ocean was
a thing never to be forgotten.

Robert Louis Stevenson

115

*A view of Castello di Amorosa's courtyard. The winery's design
is reminiscent of a Tuscan castle, which reflects their mission to
balance Old World style with the Napa Valley terroir.*

WE create 'living soil'—
soil that nourishes itself.
We consider ourselves
stewards of the land, with
our goal being to create
vineyards that will not
only endure, but improve
over time. We seek to
accomplish this in a way
that preserves the viability
of the land for future
generations.

Ralph Riva, vintner

*Fall vines near Calistoga on the Silverado Trail.*

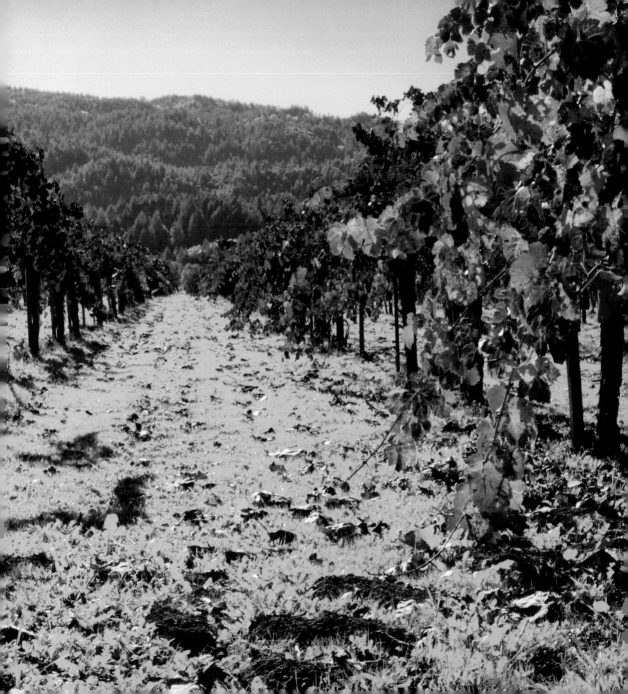

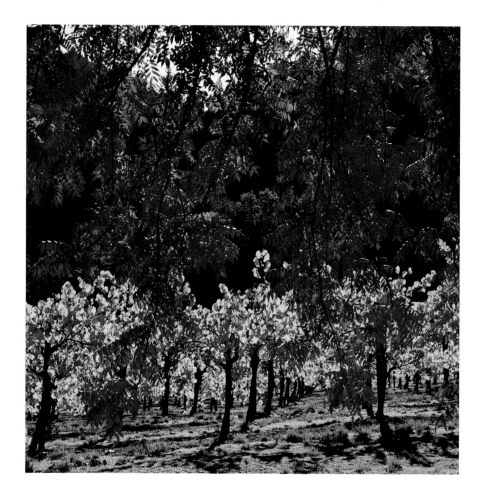

*Chardonnay vines at Stony Hill.*

*A selection of cheeses at the Oxbow Public Market, which specializes*
*in artisanal and local food.* (opposite)

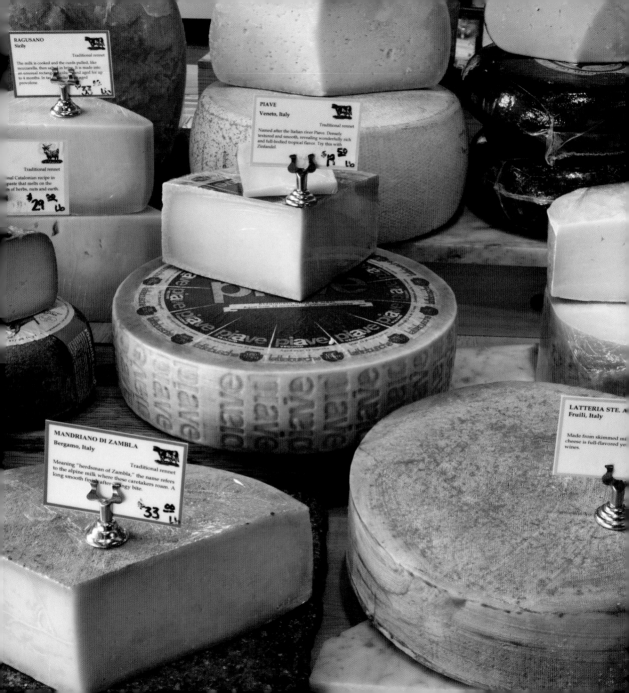

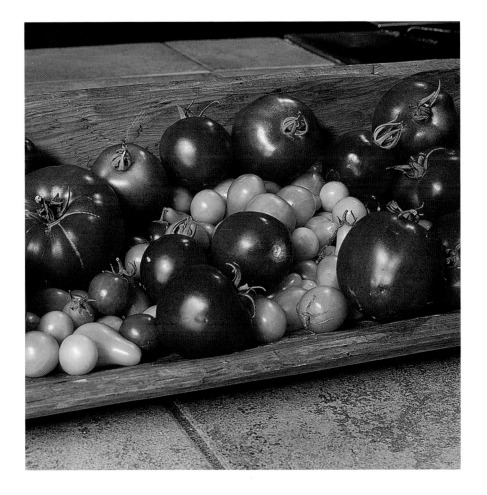

*Tomatoes grown in the organic garden of Maria Helm Sinskey at the Robert Sinskey Vineyards and Winery in the Stags' Leap Viticultural area.*

*The Bardessono resort, a 62-room hotel, spa, and restaurant in Yountville.* (opposite)

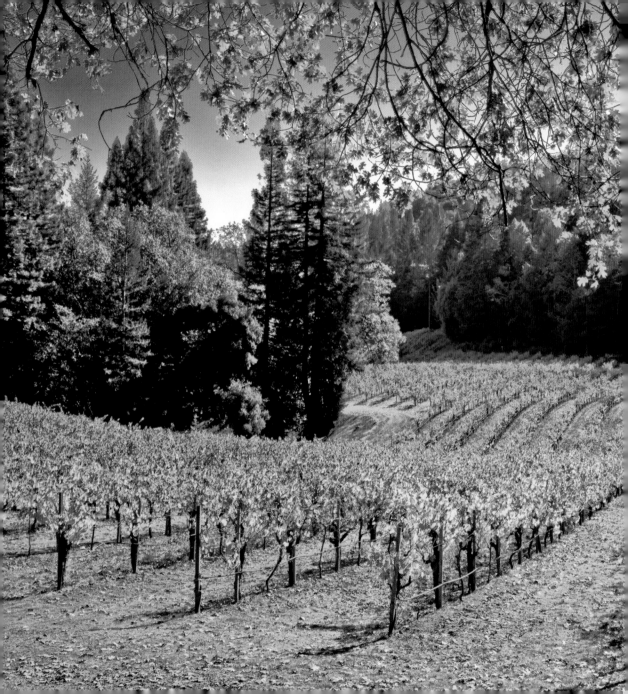

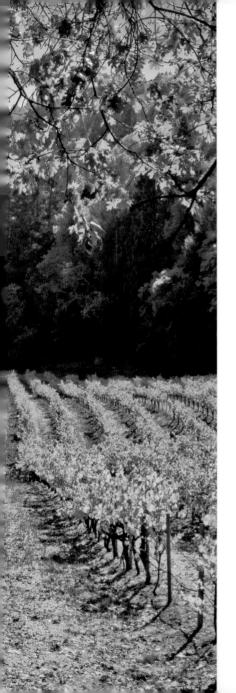

WINE is earth's

answer to the sun.

Margaret Fuller 123

*Fall vineyards at Stony Hill.*

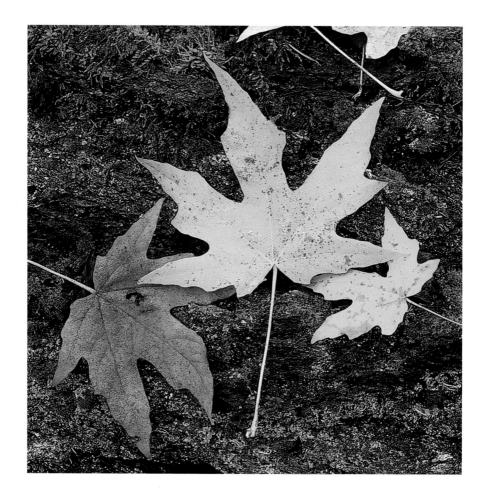

*Maple leaves on a fallen pine log on the drive to Peter and Willinda McCrea's Stony Hill Vineyard.*

*Rock sculptures by artist and Napa Valley resident Richard Botto, on the grounds of Domaine Chandon, the first French-owned sparkling wine venture in the United States.* (opposite)

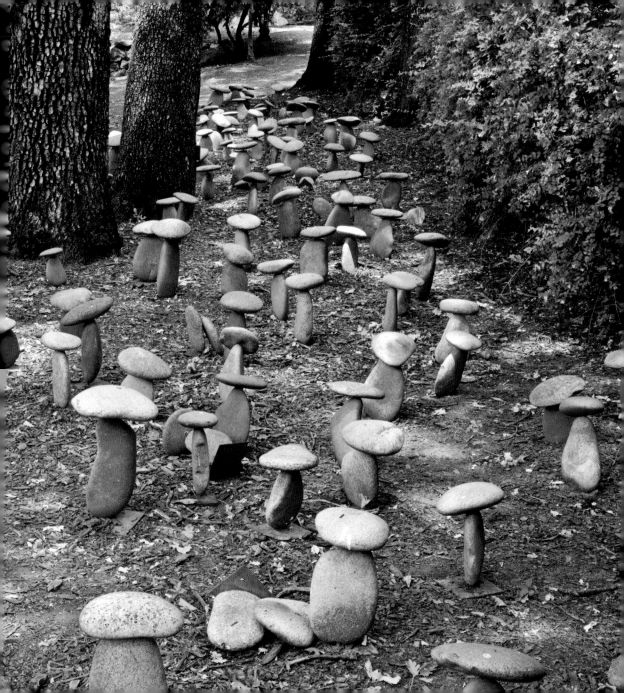

I resisted the charms of the Napa Valley for years, preferring, I thought, the rusticity and diversity of neighboring Sonoma County. Not being a wine maven, I neglected to look at, to feel, the power and beauty of Napa. There is an inevitable, almost British, orderliness to Napa, as if the great Landscape Architect in the sky created it all of a piece.

L. John Harris, food writer

*Glorious fall colors light up the vineyards of Kuleto Estate. The 800-acre Napa Valley ranch of restauranteur Pat Kuleto is situated in the rolling hills above Lake Hennessey.*

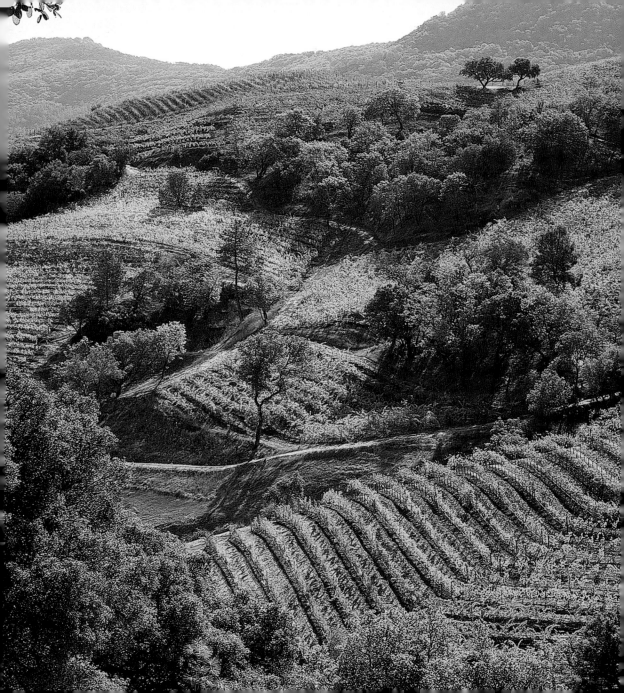

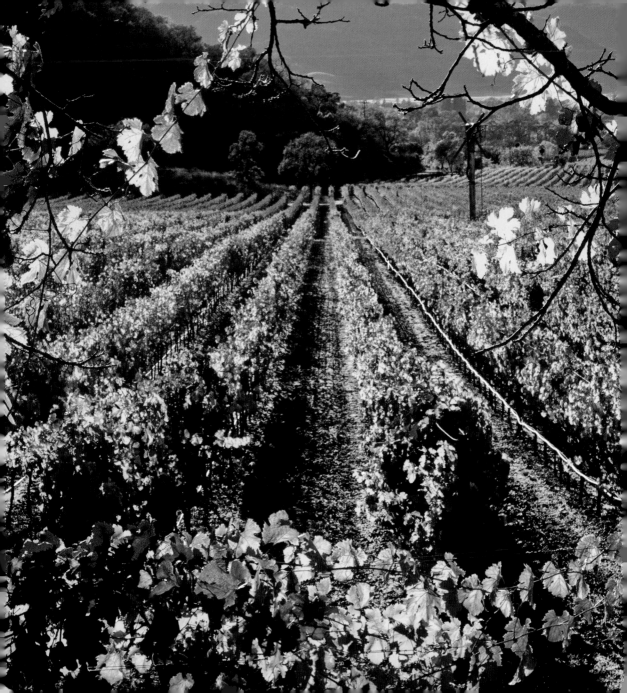

I can no more think of my own life without thinking of wine and wines and where they grew for me and why I drank them when I did and why I picked the grapes and where I opened the oldest procurable bottles, and all that, than I can remember living before I breathed. In other words, wine is life, and my life and wine are inextricable. And the saving grace of all wine's many graces, probably, is that it can never be dull. It is only the people who try to sing about it who may sound flat. But wine is an older thing than we are, and is forgiving of even the most boring explanation of its *élan vital*.

M.F.K. Fisher, gourmet

*Looking west from Stags Leap.*

WHAT wondrous life is this I lead!

Ripe Apples drop about my head!

The Luscious Clusters of the Vine

Upon my mouth do crush their Wine...

Andrew Marvell

*Apples ready for harvest at Walker Vineyard.*

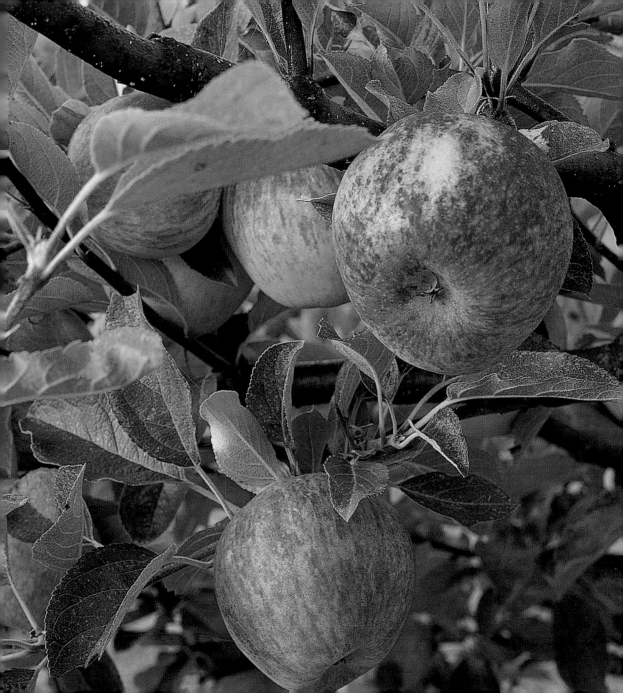

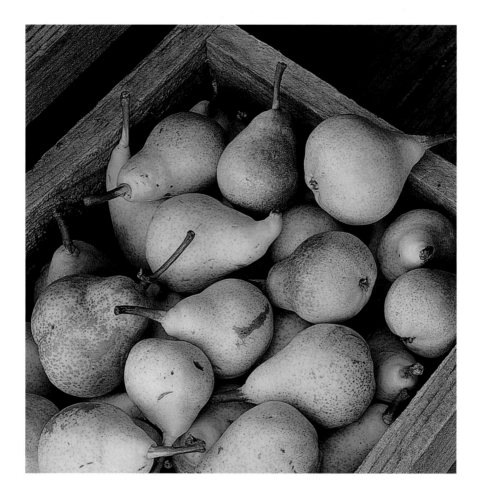

*Pears from the organic gardens at Frog's Leap Winery in Rutherford.*

*V. Sattui Winery in St. Helena. V. Sattui makes over forty different wines, which are sold exclusively through the winery.* (opposite)

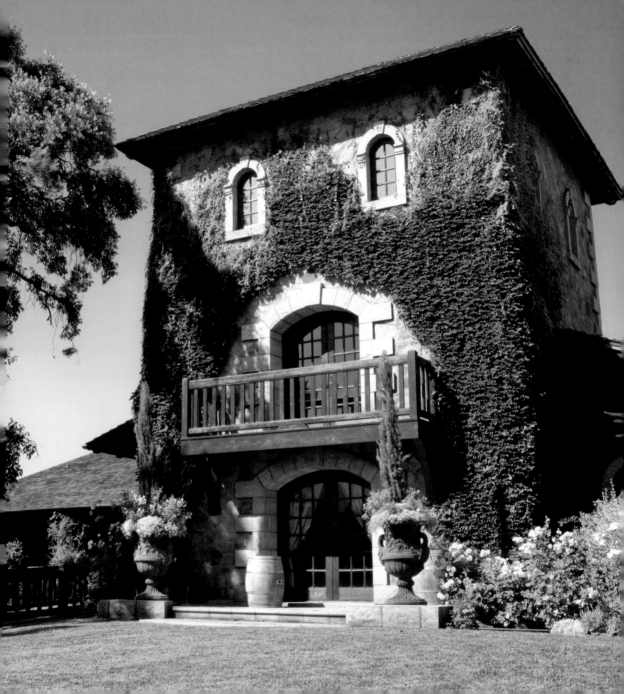

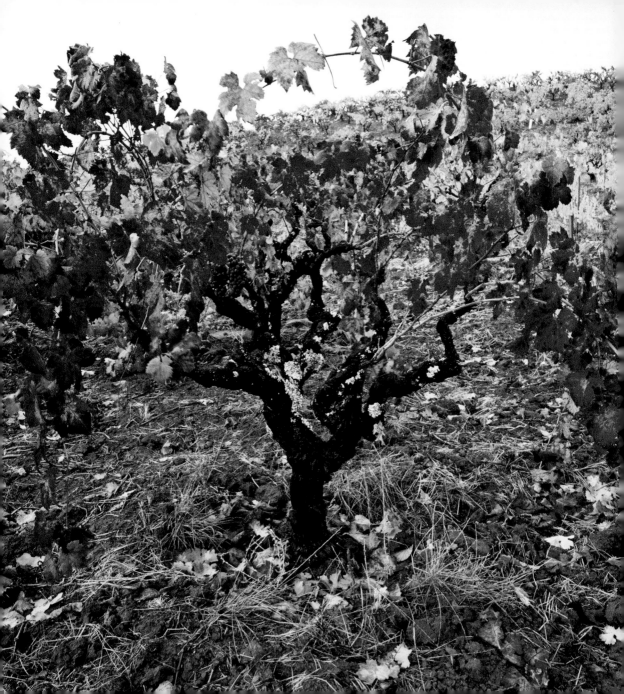

INTO the sweeping floor of vineyards, that heady intoxicating fragrance of grapes being harvested fills the air. The sun is reflecting off the turning fall leaves on the vines like a golden carpet. The road turns and follows along a meandering creek shrouded by a dense canopy of trees.

Sally James, cookbook author

*The "Old Zin" vineyard on Cuvaison's Brandlin Ranch in the fall.*

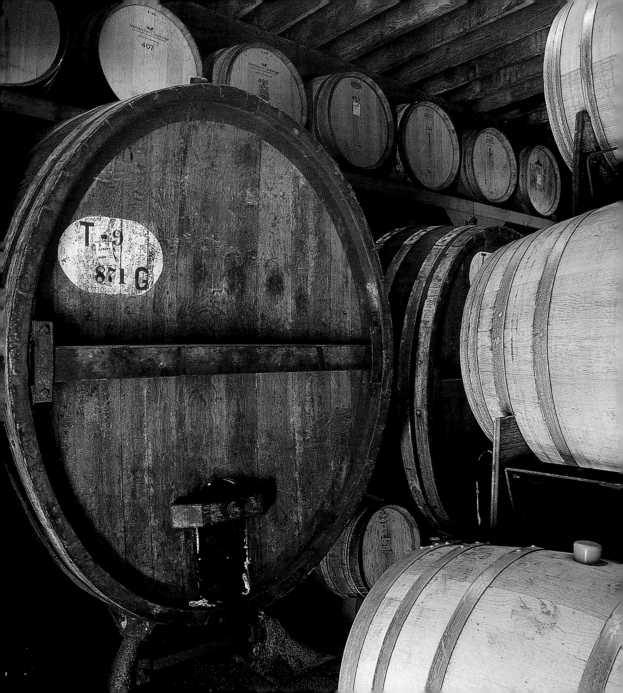

# WINTER

WINE is music

from the vineyard.

Marilyn Clark, vintner

*Oak oval and barrels in aging cellar at Mayacamas Winery and Vineyards.* (preceding spread)

*"Old Zin" vines following bud break on Cuvaison's Brandlin Ranch.*

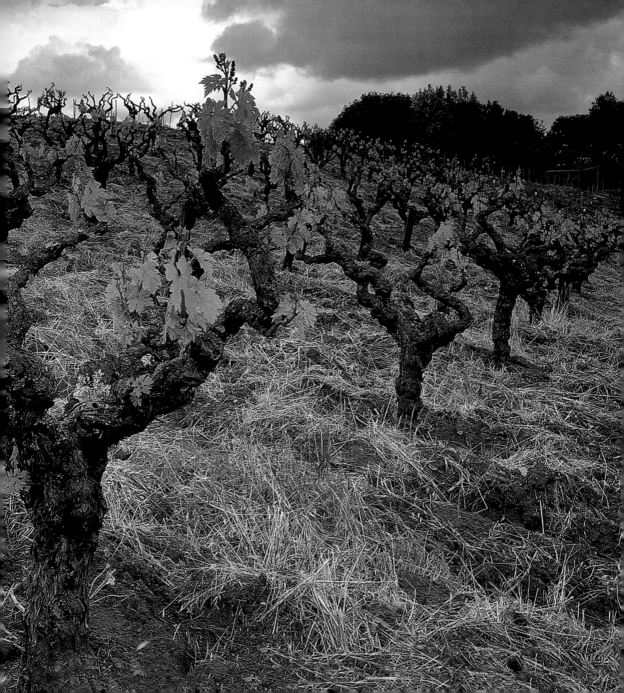

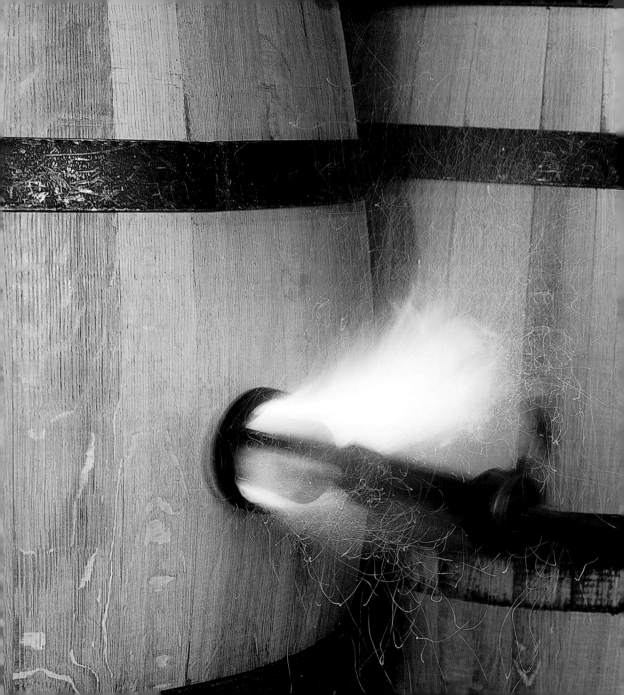

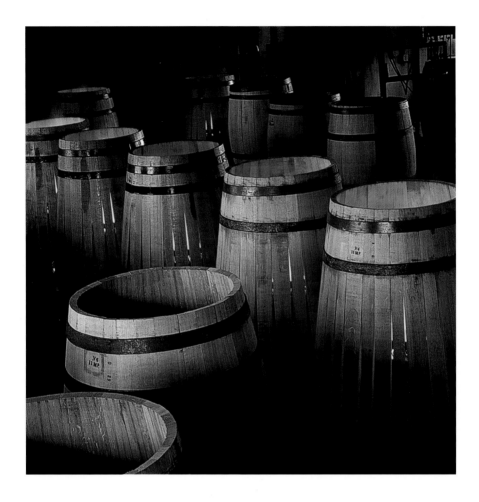

*Demptos Cooperage in Napa. Heating the oak staves to bend
into the shape of a barrel and burning the bunghole.*

THE geography of wine is as much an emotional landscape as it is a physical terrain.

Anthony Dias Blue

*Sunset over the Mayacamas Mountains.*

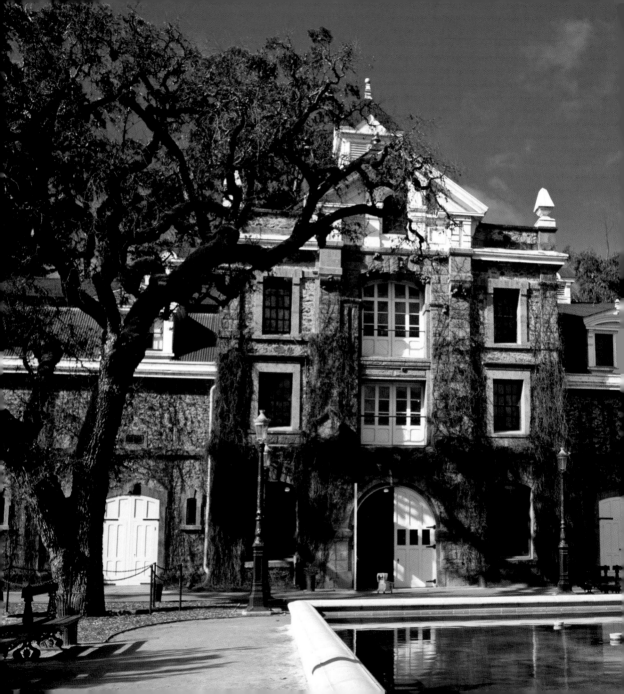

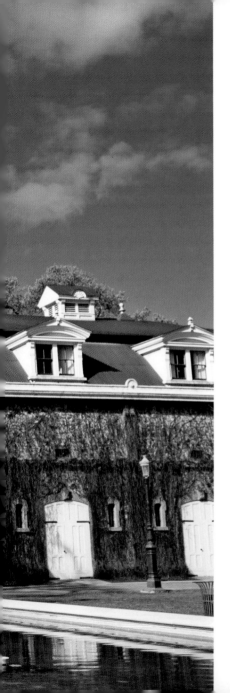

WINEMAKING is part agriculture and part parenting. We are proud to introduce you to what we have worried over and cared for—our wines. They are meant to be shared and enjoyed among friends.

<div style="text-align: right">Gene and Katie Trefethen, vinters</div>

145

*Exterior of the Rubicon Estate Winery, formerly the Niebaum-Coppola Winery.*

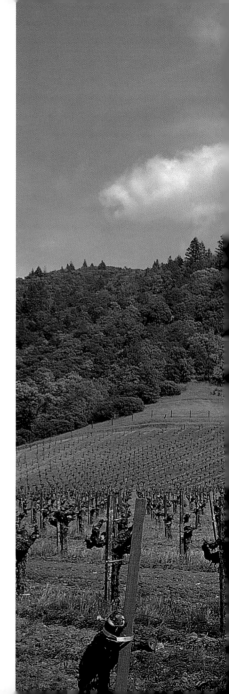

WINE is a look into the
heart of a place.

Karen MacNeil, wine connoisseur

*This old vineyard is on the Silverado Trail in Calistoga.
It's owned and farmed by winegrower Roy Enderlin,
and named "Rattlesnake Acres" due to the large
number of rattlesnakes found on the property.*

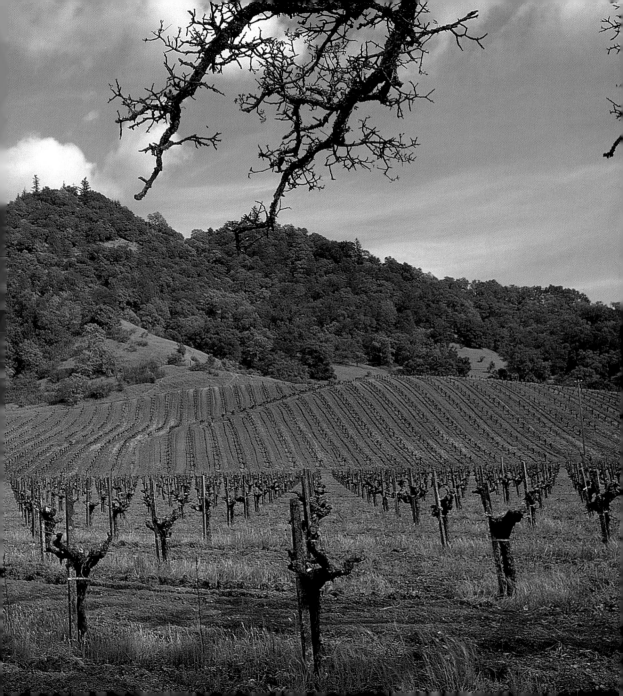

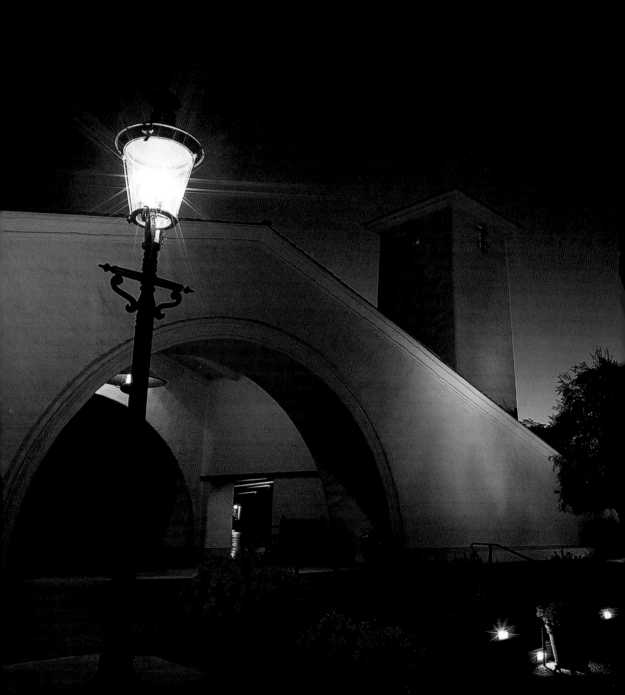

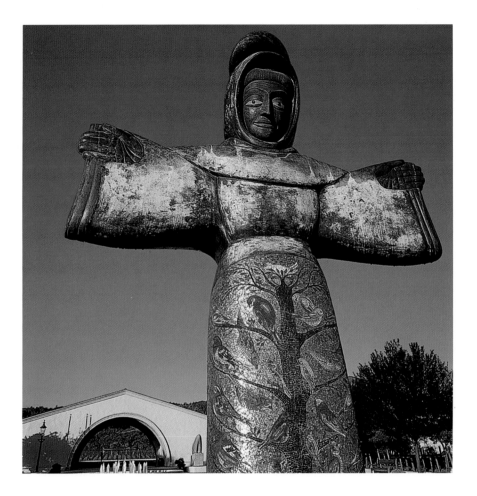

149

*Robert Mondavi Winery in Oakville was started by the patriarch of the valley in 1966.*
*Its design by architect Cliff May blends California Mission with 1960s Ranch-style architecture.*
*Statue of St. Francis by Bufano at the Robert Mondavi Winery in Oakville.*

*The barrel aging cellar at the historic Stags' Leap Winery. The cave was excavated by Chinese laborers*
*in the 1890s into the volcanic tufa of the Stags Leap Palisades.* (following spread)

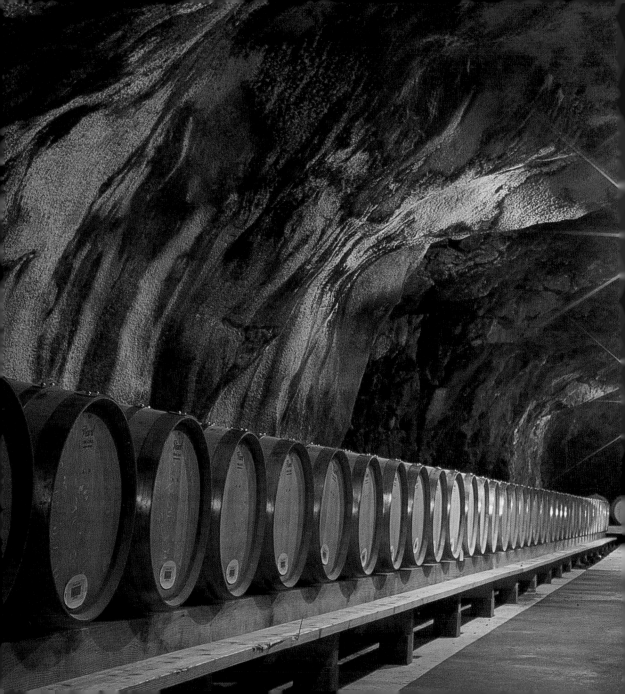

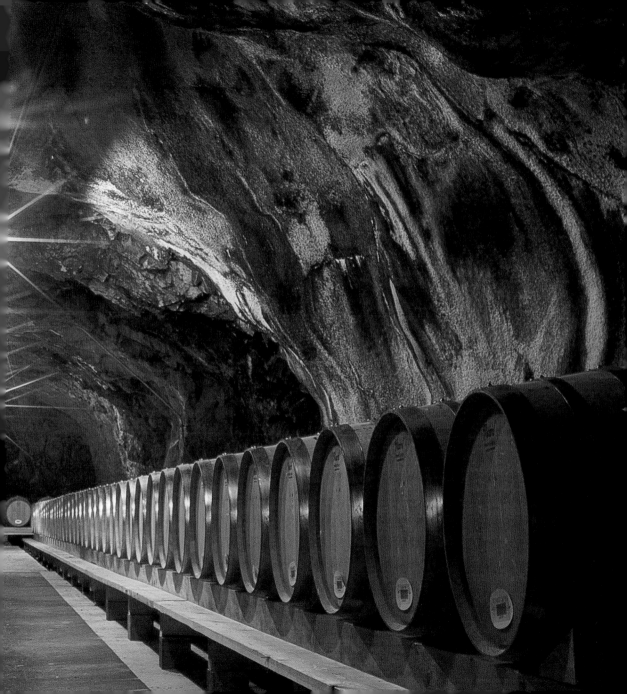

I believe in wine as I believe in Nature. I cherish its sacramental and legendary meanings, not to mention its power to intoxicate, and just as Nature can be both kind and hostile, so I believe that if bad wine is bad for you, good wine in moderation does nothing but good.

Jan Morris, travel writer

152

*Tours of Castello di Amorosa's castle-winery are offered year round.*

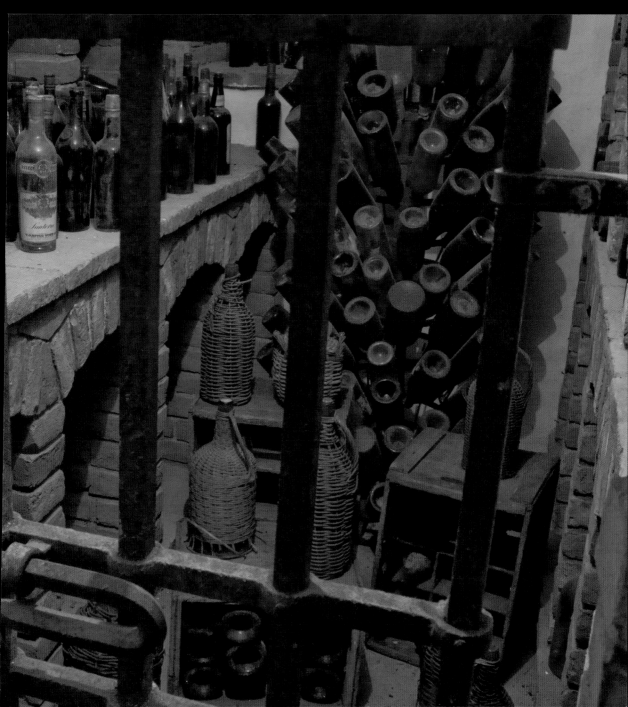

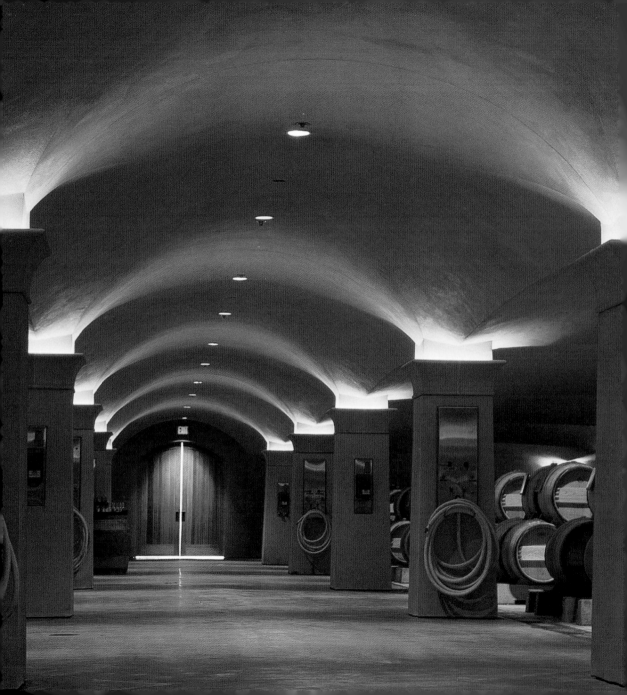

OLD wines are always a reminder of fine days, the past regained. Popular wisdom is right: Wine really is bottled sunshine; that is why it is a cheerful drink, warmth to the heart and soul.

Emile Peynaud, wine educator

155

*Barrel aging cellar at Nickel & Nickel Winery in Oakville.*

*Bistro Don Giovanni, St. Helena Highway, at Howard Lane in Napa.*

*The Historic Opera House in downtown Napa. Built in 1879 and now a national historic landmark, the Napa Valley Opera House was the center of community life during its heyday, playing host to luminaries such as Jack London, John Philip Sousa, and the legendary soprano Luisa Tetrazzini. Vaudeville shows, masquerade balls, and Temperance rallies were regular fare. The hall went dark in 1914, a victim of changing times. Recently restored, it reopened in 2003. (opposite)*

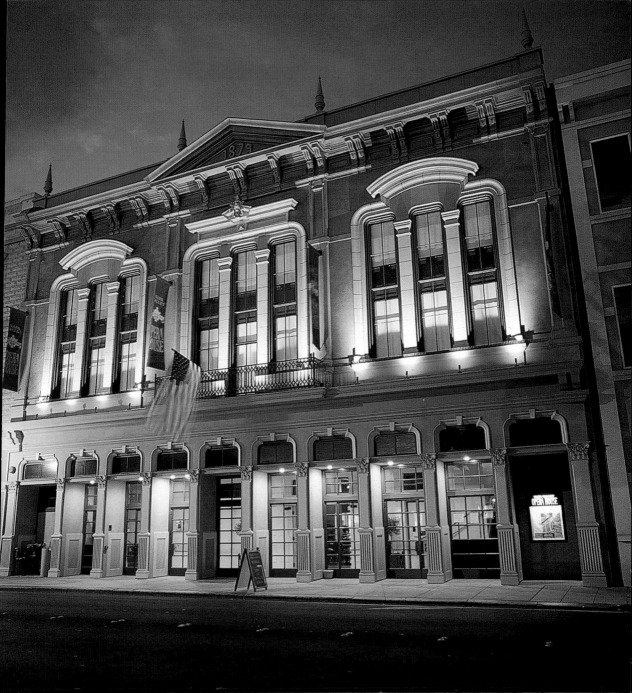

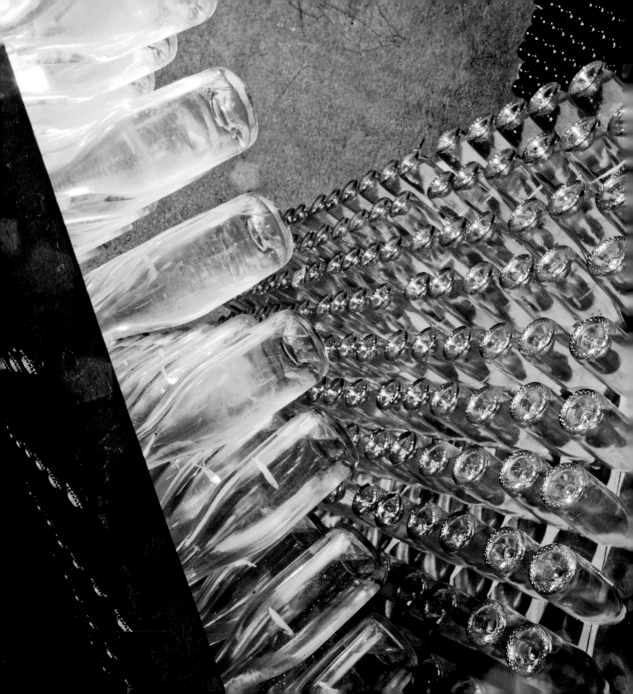

I learned from that early age
to respect wine but not be
awed by it. . . . Wine spilled
on the table was hailed as a
sign of good luck. A bad stain
maybe, but good luck.

Richard Sterling, travel/food writer

*Bottles of sparkling wine in riddling racks at Schramsberg Vineyards.*

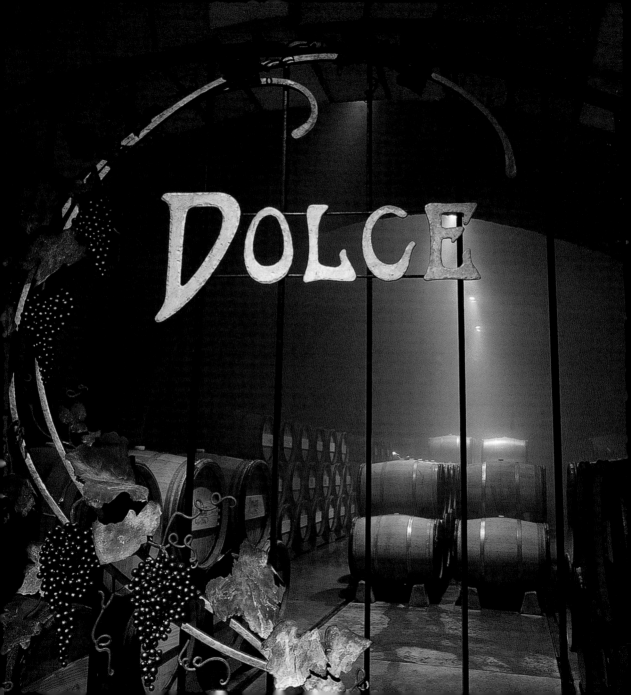

*The tasting Room at Kuleto Estate Family Vineyard.*

*The wine cave at the Dolce Winery, the only winery in North America devoted to producing a single, late harvest wine.* (opposite)

WINE comes in at the mouth

And love comes in at the eye;

That's all we shall know for truth

Before we grow old and die.

William Butler Yeats

*Designed by architect Calvin Straub, the Peju Winery Tower is one of the tallest and most unique buildings in Napa. The centerpiece stained glass window was created in 1906 and depicts the three Greek graces in a beautiful garden.*

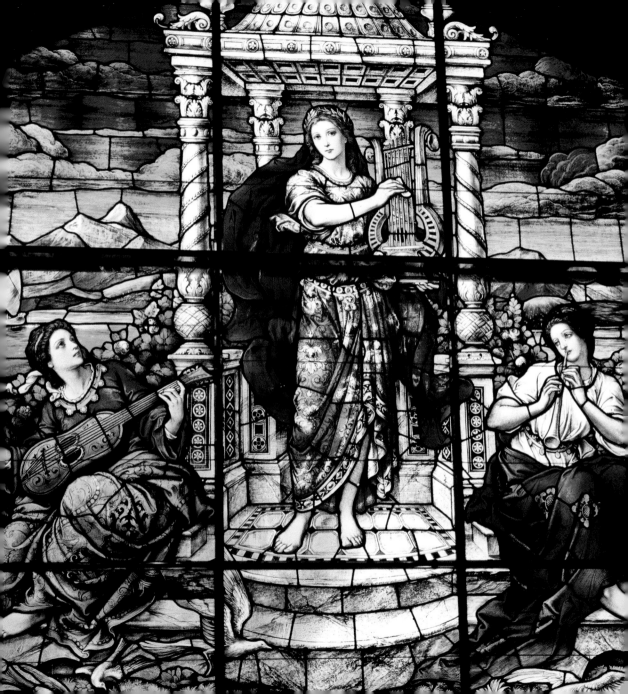

I have always used the term winegrower rather than winemaker because it better expresses my belief that the personality of a great wine is a manifestation of its terroir—the distinct soil, climate, and people involved in the process. The love of wine is inextricably linked to a respect for the land and what it brings us. Wine is grown, and we meticulously cultivate our vineyards in order to ensure that eventually there is a clear sense of place in the glass.

165

Tim Mondavi, winegrower

*Established in 1885, Far Niente prospered until the onset of Prohibition in 1919, when it was abandoned. Sixty years later, Oklahoman Gil Nickel purchased the old winery. During restoration, "Far Niente," which romantically translated from the Italian means "without a care," was discovered carved in stone on the front of the building.*

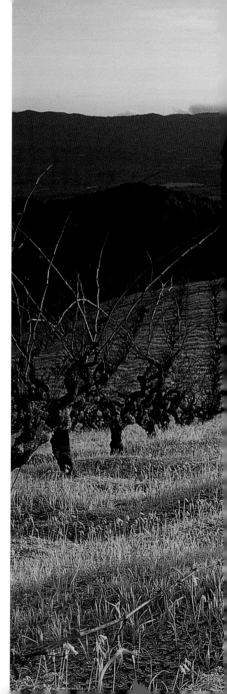

BOUNDED by coastland, desert and forest, shaped by forces older than dinosaurs, Napa Valley is truly a one-of-a-kind gift of nature.

Dawnine Dyer, viticulturist

*A winter sunrise over the "Old Zin" vineyard on Cuvaison's Brandlin Ranch.*

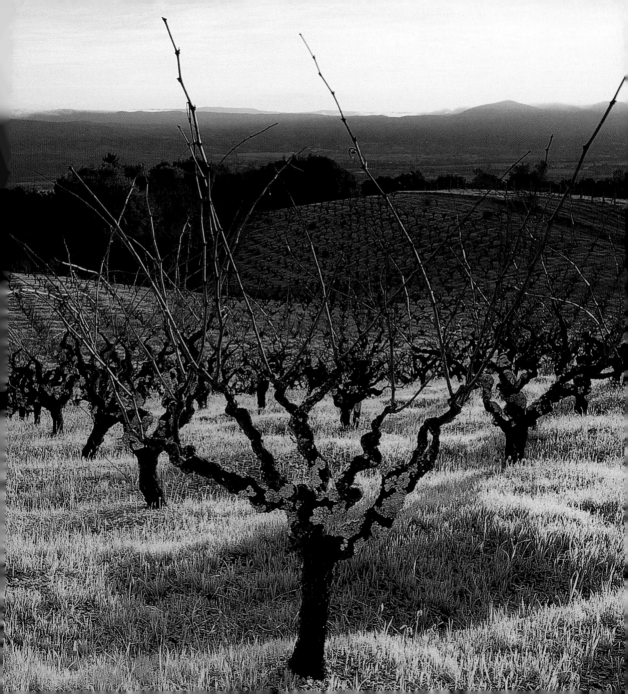

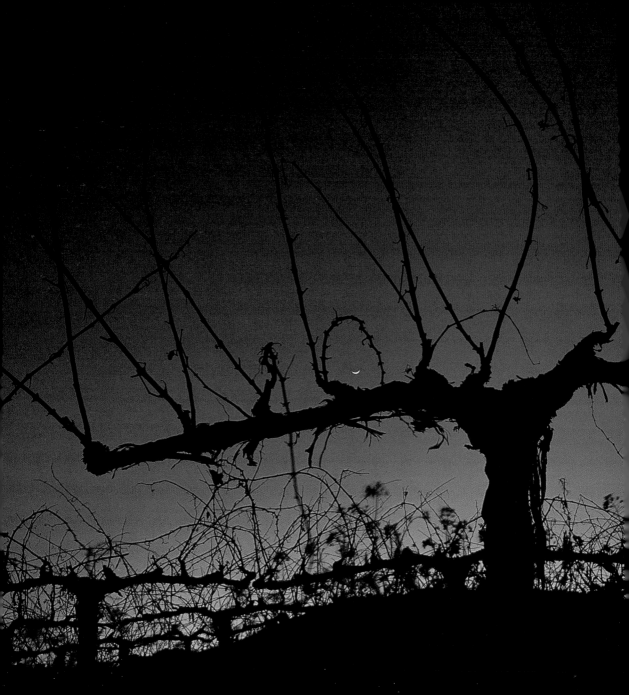

A crescent moon and
a shining star in the
luminous dusk above
the jagged Mayacamas
mountains. "Islam rises,"
murmured Walter Landor.
There was a party going
on, of course. There always
is, in the Napa Valley.

Herb Caen

*A close up of a Chardonnay vine waiting to be pruned
after harvest, shot against a spectacular hillside sunset.*

**Antica Napa Valley**
3700 Soda Canyon Road
Napa, CA 94558
ph: 707.257.8700
www.anticanapavalley.com
[PAGES: 9, 70–71, 72–73]
*Antica's spectacular property is located high atop a plain in the eastern mountains of the Napa Valley, chosen by the Antinori family not only for the breathtaking landscape, but for the rocky soils and high elevation that makes the area ideal for winegrowing. The winery specializes in limited production Cabernet Sauvignons and Chardonnays.*

**Artesa Vineyards & Winery**
1345 Henry Road
Napa, CA 94559
ph: 707.224.1668
www.artesawinery.com
[PAGES: 13, 16–17, 21]
*Opened in 1991 as Codorniu Napa and dedicated to méthode champenoise sparkling wine production, it wasn't until 1997 that Artesa converted to the production of ultra-premium still wines, releasing their first vintages in 1999 under the Artesa Winery label. They now focus on four major varietals—Chardonnay, Pinot Noir, Merlot, and Cabernet Sauvignon.*

**Bardessono**
6526 Yount Street
Yountville, CA 94599
ph: 707.204.6000
www.bardessono.com
[PAGE: 120]
*One of the newest getaways in Napa Valley, Bardessono is a 62 room hotel, spa, and restaurant. It is also one of the greenest luxury resorts in America, featuring 100,000 square feet of reclaimed wood, and 72*

170

geothermal fields for heating and cooling.

**Beaulieu Vineyard**
1960 St. Helena Highway
Rutherford, CA 94573
ph: 707.967.5233
www.bvwines.com
[PAGES: 98–99]
*One of the oldest wineries in the Napa Valley, Beaulieu was founded by Georges da Latour in 1900, and was one of the few to continue operating during Prohibition—by producing sacramental wine for the Catholic Church. 2008 saw the completion of a state-of-the-art winery dedicated to the production of the flagship Georges da Latour Private Reserve Cabernet Sauvignon.*

**Beringer Vineyards**
2000 Main Street
St. Helena, CA 94574
ph: 707.967.4412
www.beringer.com
[PAGE: 46]
*The Beringer Winery was founded in 1876 by Jacob and Frederick Beringer, German immigrants who sought out rocky, well drained soils comparable to those in their native Rhine Valley. The estate features elaborate gardens and stately 19th century architecture, offering a glimpse into one of Napa's earliest wineries. In 2001, the estate was named a Historic District on the National Register for Historic Places.*

**Bistro Don Giovanni**
4110 Howard Lane
Napa, CA 94558
ph: 707.224.3300
www.bistrodongiovanni.com
[PAGE: 156]
*Bistro Don Giovanni offers a warm Tuscan ambience in the heart of Napa Valley. This*

much-loved Italian restaurant has outdoor terraces for al fresco dining, providing spectacular views of the surrounding mountains and gardens. Guests can even take away bottles of home cured, pressed olives that come from the surrounding trees.

**Bottega Napa Valley**
6525 Washington Street
Younville, CA 94599
ph: 707.945.1050
www.botteganapavalley.com
[PAGE: 109]
*The restaurant of acclaimed chef and longtime Napa Valley resident Michael Chiarello, Bottega blends California style with regional Italian cuisine. The atmosphere matches the menu in reflecting both the rustic and refined—two indoor dining rooms feature large timber tables as well as Murano glass chandeliers, and two inviting fireplaces punctuate an impressive outdoor Terrazo.*

**Bouchon Bakery**
6528 Washington Street
Yountville, California 94599
ph: 707.944.2253
www.bouchonbakery.com
[PAGES: 26, 27]
*Bouchon Bakery was originally created by chef Thomas Keller to provide bread for his nearby restaurants, The French Laundry and Bouchon, before opening up to the entire community in 2003. All recipes are based on traditional French baking techniques.*

**Brix Restaurant and Gardens**
7377 St. Helena Highway
Napa, CA 94558
ph: 707.944.2749
www.brix.com
[PAGE: 69]
*A new incarnation of the wine country classic,*

*Brix specializes in garden-to-table dining. More than two acres of gardens and orchards provide ingredients for a menu inspired by the culinary traditions of the winegrowing regions in Southern France and Northern Italy.*

## Cakebread Cellars

8300 St.Helena Hwy
Rutherford, CA 94573
ph: 800.588.0298
www.cakebread.com
[PAGE: 97]

*Cakebread Cellars has vineyard properties located throughout Napa Valley and recently added a location in the Anderson Valley, but the winery ranches surrounding the production facility in Rutherford are where it all began. The first 22 acre parcel was purchased in 1972.*

## Castello di Amorosa

4045 North Saint Helena Highway
Calistoga, CA 94515
ph: 707.967.6272
www.castellodiamorosa.com
[PAGES: 114–115, 152–153]

*The Castello di Amorosa is a 121,000 square foot winery, built in the style of an authentic 12th century Tuscan castle. Built by Dario Sattui in 1994, the castle sits nestled in 171 acres of high elevation vineyards in the heart of Napa Valley's Diamond Mountain District, a grape growing region known for its rich, powerful red wine.*

## Chateau Montelena Winery

1429 Tubbs Lane
Calistoga, CA 94515
ph: 707.942.5105
www.montelena.com
[PAGES: 90, 91]

*Located at the base of Mount Saint Helena (the Chateau's name is a contracted form of the mountain's), the winery was founded in 1882, and produced a stunning 50,000 cases in 1886. Chateau Montelena established California as a world-class wine maker when it's Chardonnay won a 1976 tasting*

*competition in Paris, beating out four white Burgundies and five other California Chardonnays.*

## Culinary Institute of America at Greystone

2555 Main Street
St. Helena, CA 94574
ph: 707.967.1100 / 707.967.1010
(restaurant)
www.ciachef.edu/california
[PAGES: 22, 23]

*Situated like a castle on the picturesque western hills of the Napa Valley, the CIA at Greystone offers programs and classes for culinary professionals, wine professionals, and food enthusiasts. The Wine Spectator Greystone Restaurant features local, seasonal ingredients, and boasts an exclusive sparkling wine, the Querenica Brut Rose.*

## Cuvaison Estate Wines

4550 Silverado Trail
Calistoga, CA 94515
ph: 707.942.6266
www.cuvaison.com
[PAGES: 31, 45, 134, 138–139, 166–167]

*Founded in 1969, Cuvaison focuses on controlling all aspects of vineyard farming in order to produce the best possible fruit and avoid over manipulation at the winery. In addition to their hand crafted Chardonnays, Pinot Noirs, and Merlots, Cuvaison produces an elegant Cabernet Sauvignon from the grapes of the historic Brandlin Vineyard.*

## Darioush Winery

4240 Silverado Trail
Napa, CA 94558
ph: 707.257.2345
www.darioush.com
[PAGE: 108]

*Darioush is noted for its Bordeaux style estate wines, and combines old world labor-intensive, micro-vineyard management and new world state of the art technology to craft fine wines from its estates in the Napa Valley, Mt. Veeder and Oak Knoll.*

## Dean & Deluca

607 South St. Helena Highway
St. Helena, CA 94574
ph: 707.967.9880
www.deananddeluca.com
[PAGE: 96]

*Dean & Deluca is a retailer of gourmet and specialty foods, premium wines, and high-end kitchenware. The St. Helena location features local produce, cheese from local artisans, and 1400 Californian wines.*

## Demptos Cooperage Napa

1050 Soscol Ferry Rd
Napa, CA 94558
ph: 707.257.2628
www.demptosusa.com
[PAGES: 140, 141]

*The Napa Valley branch of the renowned Bordeaux barrel makers, who founded the original French cooperage in 1825. In 1982, the Napa branch was opened to manufacture and sell barrels in the US, Canada, Mexico, Chile, Argentina, Australia, and New Zealand.*

171

## Dolce Winery

1350 Acacia Dr
Oakville, CA 94562
ph: 707.944.8868
www.dolcewine.com
[PAGE: 160]

*Located within the caves of its sister winery, Far Niente, Dolce is the only winery in North America that is solely devoted to producing a single, late harvest wine.*

## Domaine Chandon

1 California Drive
Yountville, CA 94599
ph: 707.944.2280
www.chandon.com
[PAGE: 125]

*Founded in 1973 by Moet-Hennessy, Domaine Chandon is the first California sparkling wine producer to be established by a French house and use only the traditional methods of production. Exhibits by exceptional local artists are featured all*

over the expansive property, including in the acclaimed restaurant, etoile.

## Duckhorn Vineyards
1000 Lodi Lane
St. Helena, CA 94574
ph: 866.367.9945
www.duckhorn.com
[PAGE: 63]
*Made up of seven estate vineyards totaling 175 acres of planted vines, the winery was founded in 1976 by Dan and Margaret Duckhorn. It has established itself as one of North America's premier producers of Bordeaux varietals, with a particular focus on the production of Merlot.*

## Far Niente Winery
1350 Acacia Drive
Oakville, CA 94562
ph: 707.944.2861
www.farniente.com
[PAGES: 112–113, 164–165]
*Far Niente was established in 1885, and since the winery's restoration by Gil Nickel in 1979 it has focused on producing two high quality varietals, a Chardonnay and a Cabernet Sauvignon. The 13-acre property surrounding the winery is known for its gardens, which feature 8,000 southern azaleas—the largest single planting of that type in California—a beautiful sight when they bloom in spring.*

## Frog's Leap Winery
8815 Conn Creek Road
Rutherford, CA 94573
ph: 800.959.4704
www.frogsleap.com
[PAGES: 102, 103, 132]
*Frog's Leap uses organic grapes and dry-farming techniques to produce wines that deeply reflect the soil and climate from which they originate. One of the first Napa wineries to use solar power to run their operation, their commitment to sustainable, green business practices is also evident in the use of geothermal energy for heating and cooling.*

## HALL Winery
401 St. Helena Highway South
St. Helena, CA 94574
ph: 707-967-2626
www.hallwines.com
[PAGES: 58–59]
*A historic Napa Valley winery founded in 1885, Craig and Kathryn Hall acquired their St. Helena property in 2003, and completed construction of the first winery in California to be Gold LEED certified by the U.S. Green Building Council.*

## Harms Vineyards and Lavender Fields
3185 Dry Creek Road
Napa, CA 94558
ph: 707.257.2602
www.harmsvineyardsandlavenderfields.com
[PAGES: 84–85]
*The philosophy at Harms Vineyards is one of partnership with the land. Their chardonnay and sangiovese grapes are grown using Biodynamic® practices, and the lavender—from which they make a number of products including various arrangements of loose and bulk flowers, estate distilled oils, and hydrosols—is farmed both Biodynamically and organically.*

## Hess Collection
4411 Redwood Road
Napa, CA 94558
ph: 707.255.1144
www.hesscollection.com
[PAGES: 88–89]
*Housed in a stone building originally constructed in 1903, the Hess Collection has earned international recognition for its wine, culinary, and visitor programs. Opened to the public in 1989, the winery is most famous for an extensive contemporary art museum, part of the private collection of founder Donald Hess. It's fine wines are made from the hillside vineyards that surround the winery.*

## Joseph Phelps Vineyards
200 Taplin Road
St. Helena, CA 94574
ph: 707.963.2745
www.jpvwines.com
[PAGES: 42–43]
*Joseph Phelps Vineyards offers fantastic views of Spring Valley, St. Helena, and the Mayacamas Mountains. The more than 360 acres of vines allows for the production of almost 55,000 cases annually, including Joseph Phelps Insignia, one of California's most successful luxury blends.*

## Kuleto Estate Winery
2470 Sage Canyon Road
St. Helena, CA 94574
ph: 707.302.2200
www.kuletoestate.com
[PAGES: 127, 161]
*Situated on a hillside high up on the eastern edge of the Napa Valley, Kuleto Estate offers staggering views, from Lake Hennessey and the towns of Rutherford and St. Helena, to the winery's 761 acres of vineyards that sprawl across the mountainous terrain.*

## Long Vineyards
1539 Sage Canyon Road
St. Helena, CA 94574
ph: 707.963.2496
www.longvineyards.com
[PAGE: 86]
*Long Vineyards is located on Pritchard Hill, on the eastern hills of the Napa Valley between Stags' Leap and Howell Mountain. The winemakers here are committed to consistency and continuity, reflected in their signature Chardonnay, which is a product of grapes taken from the same vines that were planted 35 years ago.*

## Mayacamas Vineyards
1155 Lokoya Road
Napa, CA 94558
ph: 707.224.4030
www.mayacamas.com
[PAGES: 101, 136]

Located in the Mayacamas Mountains that divide the Napa and Sonoma Valleys, this winery is perched atop a dormant volcano on Mt. Veeder, and was originally built in 1889. Although the winery's primary output is premium Cabernet Sauvignon and Chardonnay, small quantities of Sauvignon Blanc, Pinot Noir, and Merlot are also produced.

## Mumm Napa
8445 Silverado Trail
Rutherford, CA 94573
ph: 707.967.7700
www.mummnapa.com
[PAGE: 75]
One of the top producers of sparkling wine in California, Mumm Napa adheres to the méthode traditionnelle in their winemaking process. A popular destination for wine country visitors, the winery features a fine art photography gallery showcasing local and international photographers throughout the year.

## Mustards Grill
7399 St. Helena Highway
Napa, CA 94558
ph: 707.944.2424
www.mustardsgrill.com
[PAGES: 66–67]
Named after the wild mustard flowers that bloom every spring in the vineyards, Mustards Grill is a renowned culinary experience in Napa Valley. The restaurant is presided over by award-winning chef Cindy Pawlcyn, who was at the forefront of the farm-to-table revolution when she opened this wine country roadhouse in 1983.

## Napa County Iris Gardens
9087 Steele Canyon Rd
Napa, CA 94558-9634
ph: 707.255.7880
www.napairis.com
[PAGES: 10, 52–53]
Located east of Napa near the end of Lake Berryessa, John and Lesley Painter's Iris Garden is one of Napa Valley's treasures and

a delight for the senses. This commercial garden specializes in tall bearded irises, though visitors will be rewarded for spending time going through the extensive catalog of iris varieties (more than 400) when the flowers bloom in spring.

## Napa River Inn
500 Main Street
Napa CA 94559
ph: 877.251.8500
www.napariverinn.com
[PAGES: 18–19]
Located on the riverfront in downtown Napa, this remarkable boutique hotel is housed within the historic Napa Mill, an area landmark established in 1884. At one point, the mill's warehouse stored fertilizers, feed, supplies, and wines for local vineyards. Now it provides visitors the backdrop to a scenic stay in the heart of the Napa Valley.

## Napa Valley Vintners
899 Adams Street, #H
St. Helena, CA 94574
ph: 707.963.3388
www.napavintners.com
[PAGE: 65]
Founded in 1944, the Napa Valley Vintners is a regional trade group with an active membership of more than 350 wineries, representing a tradition of dedicated vintners and grape growers who have worked and cared for this premier winegrowing region since the early 1800s.

## Nickel & Nickel Winery
8164 St. Helena Highway
Oakville, CA 94562
ph: 707.967.9600
www.nickelandnickel.com
[PAGES: 64, 154–155]
Nickel & Nickel was established in 1997 by the partners of Far Niente for the express purpose of producing 100% varietal, single-vineyard wines. Their desire to emphasize each vineyard's distinct personality has resulted in a collection of wines that is a

virtual map of some of the most coveted plots of land in the Napa Valley.

## Opus One Winery
7900 St. Helena Highway
Oakville, CA 94562
www.opusonewinery.com
[PAGES: 28–29]
Founded in 1978 as a joint venture between Robert Mondavi and Baron Phillipe de Rothschild, this remarkable winery seemingly rises out of the earth and is an architectural fusion of New and Old World elements. Reflective of the partnership between the founders and the design of the building, the winery produces a proprietary, ultra-premium Bordeaux-style blend.

## Oxbow Public Market
644 First Street
Napa, CA 94559
ph: 707.226.6529
www.oxbowpublicmarket.com
[PAGE: 119]
The Oxbow Public Market provides a home for local merchants who offer a wide range of artisanal food products, ranging from fresh seafood, cheeses, meats, hearth breads, and produce, to coffee, tea, ice cream and cupcakes. The market also houses full service casual restaurants, an oyster bar, wine bars, and specialty retail stores, as well as an outdoor deck for dining along the river.

## Peju Province
8466 St. Helena Highway
Napa, CA 94558
ph: 707.963.3600
www.peju.com
[PAGES: 80, 111, 163]
Founded in 1982 by Anthony and Herta Peju, this family owned operation produces a number of award-winning wines, from Cabernets to Chardonnay, as well as their Provence, a proprietary blend of red and white varietals. The Peju Tower is one of the tallest and most unique buildings in the Napa Valley, standing 50 feet tall and

173

resembling a French provincial tower. Its
most stunning feature is a 10' x 20' stained
glass window crafted in 1906 and depicting
the three Greek Graces in a garden.

## Pride Mountain Vineyards
4026 Spring Mountain Road
St. Helena, CA 94574
ph: 707.963.4949
www.pridewines.com
*A 235-acre estate tucked up in the
Mayacamas Mountain Range, Pride
Mountain Vineyards offers stunning views
of Mount St. Helena and the northern Napa
Valley. A remarkable cave system runs under
the hillside behind the winery, providing
23,000 square feet of storage for barrel aging.*

## Quixote Winery
6126 Silverado Trail
Napa, CA 94558
ph: 707.944.2659
www.quixotewinery.com
*Quixote is one of the most distinctive
wineries in Napa Valley. Eccentric, whimsical
and impressive, the building was designed
by renowned Viennese artist and architect
Friedensreich Hundertwasser, and is his
only building in the United States. Trees
and grass spring from the rooftops, next to
golden minarets; found material and organic
shapes cover the surfaces, and straight lines
are nowhere to be found. The color and
spirit of the place is reflected in the Cabernet
Sauvignon and Petite Syrah the winery
devotes itself to.*

## Robert Mondavi Winery
7801 St. Helena Highway
Oakville, CA 94562
ph: 707.226 1395
www.robertmondaviwinery.com
*Founded in 1966, Robert Mondavi Winery
has been instrumental in bringing worldwide
recognition to Napa Valley wines. The winery*

set the standard for connecting culture and
wine, with in-depth tours and tastings
complemented by regularly changing art
exhibits and outdoor concerts every summer
since 1969.

## Robert Sinskey Vineyards
6320 Silverado Trail
Napa, CA 94558
ph: 800.869.2030
www.robertsinskey.com
*Robert Sinskey Vineyards is one of the largest
and most progressive organic and biodynamic
wine producers in the Napa Valley. Their
commitment to sustainability extends to an
onsite garden, the produce from which is used
by the chefs for events at the vineyard.*

## Rubicon Estate Winery
1991 St. Helena Highway
Rutherford, CA 94573
ph: 800.782.4266
www.rubiconestate.com
*Owned by Francis Ford Coppola, the winery
used to be called Niebaum-Coppola Estate,
combining the names of the present owner
and original founder, Gustave Niebaum. In
1995 Coppola purchased the last remaining
piece of the original estate, called Inglenook
Chateau, and its surrounding vineyards.
After reuniting and restoring the original
Estate, the Niebaum-Coppola title was
retired in favor of Rubicon Estate, named
after the flagship wine.*

## Rudd Vineyards & Winery
500 Oakville Crossing
Oakville, CA 94562
ph: 707.944.8577
www.ruddwines.com
*Located along the foothills of the Vaca Moun-
tains, Rudd produces red wine varietals on its
Oakville estate. The grapes are fermented and
aged in 20,000 square feet of subterranean
caves that stretch below the winery.*

## Schramsberg Vineyards
1400 Schramsberg Road
Calistoga, CA 94515
ph: 800. 877.3623
www.schramsberg.com
*Founded by Jacob Schram in 1862,
Schramsberg was the first winery established
on Napa Valley's mountainsides, producing
European varietals. In 1965 the property,
since abandoned, was purchased by Jack and
Jamie Davies, who replanted the vineyards
and began the process of producing high
caliber sparkling wines according to the
traditional méthode champenoise.*

## Screaming Eagle Winery and Vineyards
7557 Silverado Trail
Napa, CA 94558
ph: 707.944.0749
www.screamingeagle.com
*Consisting of a private home and winery,
the Screaming Eagle property is one of the
smallest in the Napa Valley. A select block
of the 60-acre vineyard is dedicated to the
production of an incredibly rare and sought
after Cabernet Sauvignon, of which only 500
cases are sold annually.*

## Shafer Vineyards
6154 Silverado Trail
Napa, CA 94558
ph: 707.944.2877
www.shafervineyards.com
*Located in the Stags Leap region of the Napa
Valley, Shafer Vineyards was established
in 1972. After replanting and terracing the
existing hillside vineyards, the Shafer family
began production in 1978. A noted producer
of quality Cabernet Sauvignon, the winery's
Hillside Select is credited as one of the best in
the Napa Valley.*

**Silver Oak Cellars**
915 Oakville Crossroad
Oakville, CA 94562
ph: 707.944.8808
www.silveroak.com
[PAGE: 51]
*Silver Oak takes its name from its Napa Valley Estate, which is located between the Silverado Trail and the town of Oakville. The original winery was housed in a dairy barn, which burned down in 2006. The unfortunate incident allowed for the construction of an all new facility, complete with a new visitor center, tasting room, and history center. Silver Oak is renowned for their Napa Valley Cabernet Sauvignon.*

**Solage Calistoga**
755 Silverado Trail
Calistoga, CA 94515
ph: 866.942.7442
www.solagecalistoga.com
[PAGE: 94]
*Located in the uppermost end of the Napa Valley, Solage Calistoga is an 89 room, cottage-style resort and spa. The hotel is one of the greenest in California, using renewable and reclaimed wood and materials, and utilizing geothermal springs beneath the property to heat the spa's treatment rooms and soaking pools.*

**Stags' Leap Winery**
6150 Silverado Trail
Napa, CA 94558
ph: 800.640.5327
www.stagsleap.com
[PAGES: 150–151]
*One of California's earliest wine estates, wine grapes have been grown at Stags' Leap since the 1880s. The winery's stone manor house has long been a popular destination, functioning as a prominent country resort in the mid twentieth century. Now it serves as the inspiration for the winery's wine club, The Manor House Porch Society.*

**Sterling Vineyards**
1111 Dunaweal Lane
Calistoga, CA 94515
ph: 800.726.6136
www.sterlingvineyards.com
[PAGES: 40, 78, 79]
*One of the landmark wineries of Napa Valley, Sterling Vineyards sits atop a 300-foot hill which guests access by a unique aerial tram ride, offering spectacular views of the surrounding vineyards. The visitors center offers a salon-style tasting environment, as well as a self-guided tour that provides an informative look at the winemaking process from platforms elevated above the operations.*

**Stony Hill Vineyard**
3331 St. Helena Highway N
St. Helena, CA 94574
ph: 707.963.2636
www.stonyhillvineyard.com
[PAGES: 92–93, 118, 122–123, 124]
*Perched on the northeast slope of Spring Mountain in the Napa Valley, Stony Hill Vineyard was established in 1943 by Fred and Eleanor McCrea and was one of the first new wineries to be founded in the valley following Prohibition. The winery now produces around 3400 cases a year from 40 acres of vines, with the majority of the vineyard devoted to Chardonnay.*

**Truchard Vineyards**
3234 Old Sonoma Road
Napa, CA 94559
ph: 707.253.7153
www.truchardvineyards.com
[PAGE: 33]
*A small family winery in the beautiful carneros region of the Napa Valley, the estate is made up of more than 300 acres of hills and valleys, and with 10 different grape varietals, is one of the most diverse vineyards in California. Truchard's wines are handcrafted using traditional winemaking techniques, and reflect the high quality fruit of the estate.*

**V. Sattui Winery**
1111 White Lane
St. Helena, CA 94574
ph: 707.963.7774
www.vsattui.com
[PAGE: 133]
*Originally founded in 1885 in San Francisco by Vittorio Sattui, V. Sattui Winery was re-established in St. Helena in 1975 by his great-grandson Dario Sattui. Their award-winning wines are sold exclusively at the winery, which features a gourmet cheese shop and deli surrounded by two and a half acres of picnic grounds.*

**Walker Vineyard**
[FRONT COVER; PAGES: 1, 54–55, 60–61, 106–107, 131]
*Wes Walker began growing grapes in 1990, after purchasing 25 acres of land in west Napa. A retired Superior Court Judge for Napa County, Walker is also an acclaimed photographer, documenting the natural beauty of Napa Valley and beyond. Walker Vineyard produces premium Cabernet Sauvignon grapes for Silver Oak Cellars.*

**ZD Wines**
8383 Silverado Trail
Napa, CA 94558
ph: 707.963.5188
www.zdwines.com
[PAGE: 56]
*Founded in 1969, ZD Wines has enjoyed three generations of family-run winemaking. The initials stand for Zero Defects, a philosophy reflected in ZD Wines pursuit of quality and consistency, and their commitment to organic farming practices. The result is world-class Chardonnay, Pinot Noir, and Cabernet Sauvignon.*

175

Before visiting, it is recommended you contact these locations for tours, hours of operation, and additional information.

Original edition published in 2004 by Welcome Books®

Welcome Books®
An imprint of Welcome Enterprises, Inc.
6 West 18th Street, New York, NY 10011
(212) 989-3200; Fax (212) 989-3205
www.welcomebooks.com

*Publisher*: Lena Tabori
*Editor*: Peter Beren
*Art Director*: Gregory Wakabayashi
*Project Director*: Natasha Tabori Fried
*Editorial Assistant*: Gavin O'Connor
*Winery Editorial Assistant*: Eric Nelson Nørgaard

Compilation and Design © 2010 Welcome Enterprises, Inc.
Photographs and foreword © 2010 Wes Walker
Introduction © 2010 Linda Reiff

Additional copyrights below.

Library of Congress Cataloging-in-Publication Data on file

ISBN: 978-1-59962-080-0

Printed in China

First Edition

10  9  8  7  6  5  4  3  2  1

CREDITS

Pages 12, 77: *A Vineyard Year* text by Randle Johnson, The Hess Collection Winery.
Excerpted with permission from *Guide to Choosing, Serving & Enjoying Wine* by
Allen R. Balik and Virginia B. Morris. © 2000 by Lightbulb Press, Inc., 112 Madison
Avenue, New York, NY 10016. www.lightbulbpress.com. All rights reserved.

Page 16: © Copyright 2003 Roger Rapoport. All rights reserved. Used with
permission.

Page 20: Doris Muscatine, et alia, *University of California/Sotheby Book of California
Wine*. Copyright © 1984 by The Regents of the University of California.

Pages 22, 56: Photographs copyright © Marsha Johnston.

Page 32: Excerpt from *Dreamers of the Valley of Plenty* by Cheryll Aimée Barron.
Copyright © 1995 by Cheryll Aimée Barron.

Page 44: from *Escape to the Wine Country*, text by Thom Elkjer, Photographs by
Robert Holmes. Copyright © 2002 by Fodors LLC, Photographs copyright © 2002
by Robert Holmes.

Pages 49, 142: Selection by Anthony Dias Blue excerpted from the Introduction to
*Adventures in Wine* (Travelers' Tales, Inc.). Copyright © 2002 by Anthony Dias Blue.

Page 52: Excerpt from *Savor Wine Country* Fall 2003. Permission to reprint granted
by The Press Democrat.

Page 58: Quotation from *From the Grounds Up, Shafer Vineyards First 25 Years*,
Napa, 2004

Page 62: Quotation from *Inventing the Dream: California through the Progressive
Era*, Oxford, 1985.

Page 74: Quotation from *The Science Behind the Napa Valley Appellation*, St.
Helena: Napa Valley Vintners, 2007

Page 81: Excerpt from *Gardens of the Wine Country* by Molly Chappellet. © 1998 b
Chronicle Books, San Francisco.

Page 82: Excerpted with permission from *Guide to Choosing, Serving & Enjoying
Wine* by Allen R. Balik and Virginia B. Morris. © 2000 by Lightbulb Press, Inc.,
112 Madison Avenue, New York, NY 10016. www.lightbulbpress.com. All rights
reserved.

Page 84: © Copyright 2003 Reverend Brad Bunnin. All rights reserved. Used with
permission.

Page 89: Excerpts from *NAPA: The Story of American Eden* by James Conaway.
Copyright © 1990 by James Conaway. Reprinted by permission of Houghton
Mifflin Company. All rights reserved.

Page 99: Quotation from *Old Napa Valley: History to 1900* by Lin Weber. © 1998
Wine Ventures Publishing, St. Helena.

Page 110: Excerpt from *The Best Places to Kiss in Northern California: A Romantic
Travel Guide* by Stephanie C. Bell & Elizabeth Janda. Reprinted with permission of
Beginning Press.

Page 115: Excerpt from *The Silverado Squatters* by Robert Louis Stevenson. © 1895
by Stone and Kimball.

Page 126: Copyright 2003 L. John Harris, author of *The Book of Garlic* and
Producer/Director of the award-winning PBS documentary, Los Romeros: The
Royal Family of Guitar.

Page 129: from *The Story of Wine in California*, text by M.F.K. Fisher.

Page 152: Excerpt from *Traveler's Tales Adventures in Wine*. Reprinted by
permission of Jan Morris.

Page 155: Excerpt from *The Taste of Wine: The Art and Science of Wine Appreciation*
by Emile Peynaud. Copyright © 1996. Reprinted by permission of John Wiley &
Sons, Inc.

Page 159: Excerpt from *Traveler's Tales Adventures in Wine*. Reprinted by
permission of Richard Sterling.

Page 165: Excerpt from the foreword to *From Vines to Wines: The Complete Guide to
Growing Grapes and Making Your Own Wine* by Jeff Cox. Reprinted by permission
of Storey Publishing.